IMAGES
of America

OYSTERVILLE

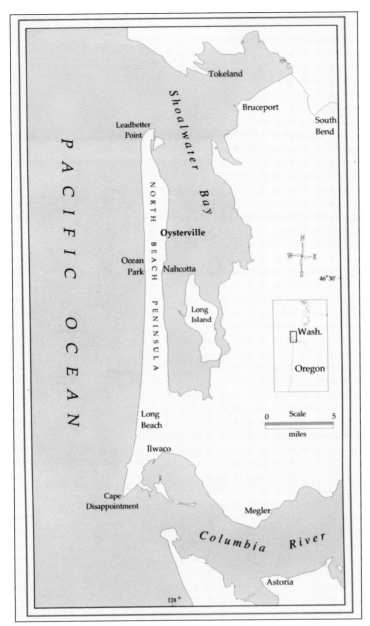

OYSTERVILLE. Shoalwater (now Willapa) Bay formed some 10,000 years ago and, in time, became partially enclosed by the buildup of sands washing north from the Columbia River's mouth. The resulting long, narrow sand spit was called North Beach Peninsula by early travelers to differentiate it from Oregon beaches to the south. Oysterville, the peninsula's first pioneer settlement, is one of the oldest continuing villages on Washington's coast. (Paul E. Staub.)

ON THE COVER: OYSTERING. The Native oysters (*Ostrea lurida*) growing in Shoalwater Bay enticed white settlers to the area in the mid-1800s, and the industry that developed has continued to evolve. In the early years, before mechanization, work was done by hand. Pictured here are Oysterville oystermen with some of the tools of their trade—wire baskets and long-handled oyster tongs. (Charlotte Jacobs.)

IMAGES
of America

OYSTERVILLE

Sydney Stevens

ARCADIA
PUBLISHING

Published by Arcadia Publishing
Charleston SC, Chicago IL, Portsmouth NH, San Francisco CA

Printed in the United States of America

Library of Congress Control Number: 2009942526

For all general information contact Arcadia Publishing at:
Telephone 843-853-2070
Fax 843-853-0044
E-mail sales@arcadiapublishing.com
For customer service and orders:
Toll-Free 1-888-313-2665

Visit us on the Internet at www.arcadiapublishing.com

*For all those who have encouraged and supported
the preservation of Oysterville.*

CONTENTS

ACKNOWLEDGMENTS

This book is a collaborative effort. It could not have happened without the generosity of the many people who have kept and gathered and treasured the images and stories of Oysterville. In particular, I would like to thank Ann "Memi" Sherwood Anderson, Virginia Ann Holway Driscoll, Dan Driscoll, Patricia Fagerland, Lisa Farnham, Larry Freshley, Ray Gardner, Charlotte Jacobs, Peter Janke, William Y. LaRue, Jackie Manning, Betsy Millard, Barbara Minard, Anne Cannon Nixon, James R. Sayce, John McNamara, Katherine Holway Smith, Judy Heckes Stamp, Paul E. Staub, Nyel Stevens, Alan Trimble, Mark Tyler, Tucker Wachsmuth, Karla Webber, Dobby Wiegardt, and Rodney Williams.

Most especially, I want to express my appreciation to Tucker Wachsmuth for sharing with me his extensive knowledge of early maritime and oystering practices on Shoalwater Bay, and to Dobby Wiegardt for reading the manuscript for accuracy regarding modern-day oystering techniques.

The images in this volume appear courtesy of the Columbia Pacific Heritage Museum (CPHM), Dan and Louis' Oyster Bar (D&L), the Espy Family Collection (EFC), the Heckes/Kemmer family (HKF), the Pacific County Historical Society (PCHS), the Sherwood family (TSF), and others as noted.

INTRODUCTION

From boomtown to ghost town to National Historic District, Oysterville on Washington's Shoalwater Bay has had a long and colorful history. The village was founded in 1854 and immediately gained acclaim for the abundance of the Native oysters (*Ostrea lurida*) growing at its doorstep.

In the fall of 1853, young Robert Hamilton Espy, recently from Pennsylvania, had been working near Bruceport, Washington Territory, on the east side of Shoalwater Bay. He was felling and limbing trees for an Astoria-based sawmill—trees destined to become pilings in San Francisco Bay. At that time, few white men lived in the Shoalwater region, and those who did were interested in the little Native oysters—also bound for the San Francisco market. The eight men of Bruceville, known as "the Bruce Boys," were hospitable to Espy; they shared their hearth and their food, and invited him to sit in on their poker games of an evening. However, they were not willing to talk about their developing oyster business.

Espy's friend Old Klickeas, a Chinook Indian from the area, was more forthcoming. He told Espy that he could show him a fine stand of oysters on the other side of the bay—oysters that the Bruceport men knew nothing about. For generations, Klickeas's people had hunted seal and gathered salmon berries on the western side of Shoalwater Bay, camping in the area that is now Oysterville. They called it *tsako-te-hahsh-eetl*, meaning "place of the red-topped grass." Klickeas and Espy agreed to meet there the following spring.

Espy wintered in Astoria, and there met Isaac Alonzo Clark, a young man of similar age and interests. They formed a partnership, and on April 12, 1854, they kept Espy's rendezvous with Klickeas. They found that Klickeas had not exaggerated. The mudflats were covered with tiny Native oysters, there for the taking. Within weeks, Espy and Clark were marketing the bivalves in gold-rich, oyster-hungry San Francisco.

Oyster schooners soon plied the waters between San Francisco and Oysterville on a regular basis, and ship captains paid $1 in gold for every bushel basket of oysters loaded aboard. Each basket brought $10 on arrival in San Francisco, and epicures in oyster bars and seafood restaurants there would pay a silver dollar for one oyster—an oyster smaller than the coin! A plateful sold for a Mexican "slug," which was worth two-and-a-half times a $20 gold piece. For lack of a bank, gold receipts in Oysterville were stashed under mattresses or buried in old tin cans for safekeeping. It is said that there was often more gold in Oysterville than in any other anchorage on the West Coast except San Francisco.

Within a few months, there were several hundred settlers in Oysterville, and in 1855, it was voted the seat of Pacific County, Washington Territory. In keeping with the town's rough-and-tumble beginnings, the first business established was a saloon. In no time at all there were seven. Commercial enterprises of all types flourished, including boat shops, general stores, butcher shops, hotels, a restaurant, stage barns, a slaughterhouse, a clam cannery, a smithy, a print shop, a newspaper, and even a casket shop. But there was never a bank, a barbershop, a laundry, or a local doctor.

The burgeoning community had many county firsts: a school, a college, a newspaper, and, finally, in 1872, a church—First Methodist. Oysterville was a rip-roarin' town in those days. There were those who lived in "sin," and those who lived to be "saved;" about an even division. When the church was dedicated, the hard drinkers abandoned the saloons, marched in a body to the church, put their gold pieces in the collection plate, and returned to what they considered more stimulating than praying—drinking.

In the late 1880s, fate took a hand: the long-awaited railroad line ended at Nahcotta, an isolating 4 miles away. The Native oysters became scarce, and without the possibility of a local livelihood, residents moved out en masse. Finally, in 1892, the county electorate voted to move the county seat across the bay to South Bend. Oysterville residents challenged the election results, but a group later referred to as "the South Bend Raiders" grew tired of waiting for the slow wheels of justice to turn. On a slushy Sunday morning when most Oysterville folks were in church, two boatloads of South Benders converged on Oysterville, broke into the courthouse, and took the records back to South Bend. Gradually Oysterville slipped into decline.

By the time Eastern oysters (*Crassostrea virginica*) were introduced to Shoalwater Bay in 1896, Oysterville had entered a period of quiet inactivity. Most oystermen and the businesses that supported oystering had moved on, and the majority of households now based their livelihood on subsistence farming. In the early 20th century, when the Easterns took hold, Oysterville was revitalized but never again equaled the prosperous years of the previous generation. When, in 1919, the Easterns, too, "failed," it seemed that Oysterville was destined to disappear as well.

Then, seemingly against all odds, a third oyster, the Japanese oyster (*Crassostrea gigas*), was introduced to Shoalwater Bay and immediately thrived. By then, just before the outbreak of World War II, the old-fashioned methods of oystering were beginning to change. Sails, oars, and paddles had given way to steam and gasoline power; handpicking and tonging were replaced by large, efficient oyster dredges; improvements in canning methods and in transportation possibilities changed and expanded the market. Once again, oystering made a comeback in Oysterville, and even though Japanese seed imports ceased during the war years, Oysterville canneries kept their work forces employed. Nevertheless, the community did not grow apace with the resurgence of the industry, and Oysterville again declined. This time felt final.

Before oblivion became complete, R. H. Espy's granddaughter came to the rescue. Dale Espy Little spent her retirement years on a "mission of mercy" for the village where she, and her father before her, had grown up. With enthusiasm and determination, she spearheaded a campaign to save the village for posterity. Her efforts and those of the community and its supporters were rewarded in 1976 when Oysterville was placed on the Register of National Historic Places by the U.S. Department of Interior's National Park Service and the Washington State Parks and Recreation Commission.

Since that time, Oysterville's residents have worked diligently to restore and preserve the remaining old buildings and to keep the historic village ambiance intact. Once more there is an oyster presence in town, and though the character of Oysterville has changed from the lusty days of its youth, visitors and residents alike often remark on the special magic that it retains.

Perhaps early school teacher Alice Holm said it best: "I remember Oysterville began where you turned the corner of Mrs. Nelson's white picket fence where the 'laylocks' bent over the gate, and with her other flowers, bubbled and bloomed in profusion. I remember the bay that spread out on the right in its Sunday evening quiet splendor. Then, looking up the one wide tree-bordered street, I remember that elusive something that suggested the passage of time—centuries—and the never failing twinge of melancholy that swept over me in spite of rich contentment."

One

Discovery

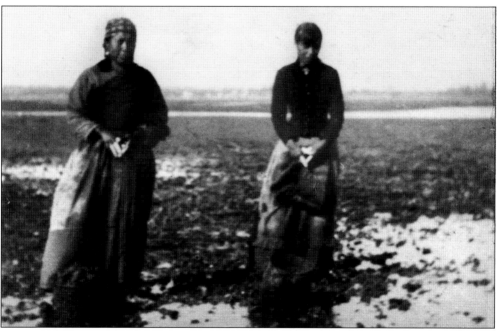

NATIVES ON SHOALWATER BAY. For generations, the Chinook Indians had gathered the succulent little Native oysters that grew abundantly in the bay tidewaters of their homeland—the body of water that, in 1788, explorer Capt. John Meares would name Shoalwater Bay. The bounteous oyster supply must have seemed never-ending to the small population of local Chinooks, whose numbers, even before white contact, never exceeded 3,000. (Tucker Wachsmuth.)

PERFECT BRINY BROTH. Though it varies by season and weather, the amount of water entering and leaving Shoalwater Bay at each tide turn averages 7.5 million gallons per second. The difference between high and low water levels may be as much as 12 or as little as 6 feet, and at an extreme low tide, more than half the bay's 70,400 acres are exposed. Seven rivers flow into the bay, and their fresh water, mixing with the salty sea, provided the perfect briny environment for propagation of the tiny *Ostrea lurida*. When, in 1850, Charles Russell, from Pacific City near Cape Disappointment, introduced the oysters into the bustling San Francisco market, demand for the delectable shellfish was immediate. (Sydney Stevens.)

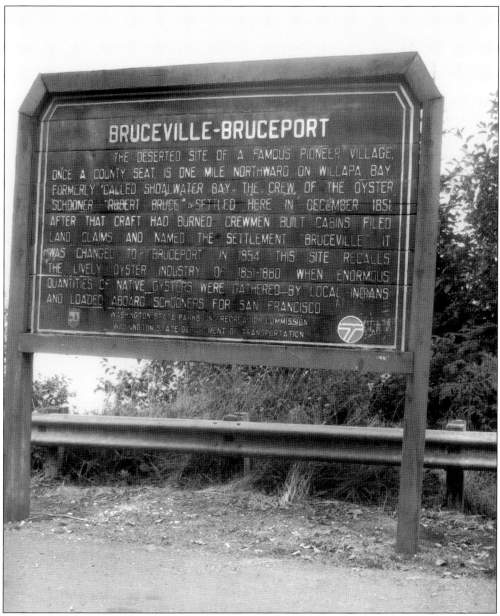

THE BRUCE BOYS. On December 11, 1851, the ill-fated *Robert Bruce* anchored in Shoalwater Bay. The 80-foot, two-masted schooner had been purchased in San Francisco by eight East Coast oystermen who had failed at their search for fortune in the gold fields of California. Learning of oyster treasure in the little-known bay to the north, the men pooled their resources, bought and outfitted the *Robert Bruce*, and headed for Shoalwater Bay. Shortly after their arrival, however, their schooner burned to the waterline. The shipwrecked prospectors, known thereafter as "the Bruce Boys," built a communal lodge on shore opposite the wrecked *Robert Bruce*, beginning Bruceville (later Bruceport), the first settlement on Shoalwater Bay. The Bruce Boys lost no time replacing their ship and establishing a foothold in the lucrative San Francisco oyster trade. Eroding sands finally allowed the bay to claim the little town and now only a roadside sign marks the location of the once-thriving community. (Sydney Stevens.)

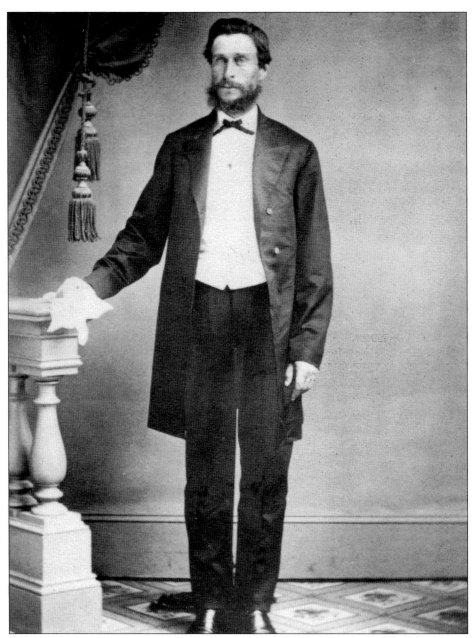

ROBERT HAMILTON ESPY. Pennsylvania-born Robert Hamilton Espy crossed the plains in 1852, arriving in Astoria, Oregon Territory, in the spring of 1853. He was 26 years old and was looking for an opportunity. Since his past experience had included some logging, he was able to find work as a timber cruiser for an Astoria sawmill. His work soon took him across the Columbia River to the east side of Shoalwater Bay, where he spent the summer and fall months. It was during this time, according to Espy family lore, that young Hamilton (his Christian name of preference) ate his first oyster. In late October, he built a log cabin on the Palix River, not far from the communal lodge of eight recently arrived Bruce Boys. They were cordial, willingly sharing their meals, their whisky, and an occasional game of poker. But when Espy expressed interest in their oystering enterprise, their hospitality abruptly ended. (EFC.)

OLD KLICKEAS. While Espy was living on the Palix River, Old Klickeas, a Chinook tribal elder, told him about a stand of oysters on the west side of Shoalwater Bay, across and somewhat south of the Bruce Boys' operation—an area he called *tsako-te-hahsh-eetl*, meaning "place of the red-topped grass." It was where Chinook families went each spring to gather salmonberries. "If you meet me there in six months," Klickeas told Espy, "I'll show you more oysters than the Bruce Boys ever dreamed of." Espy wintered in Astoria, and toward spring he met Isaac Clark, who was about the same age, also enjoyed playing poker, and was interested in seeking his fortune. In April, the two headed for Espy's rendezvous with Klickeas. (Lisa Farnham.)

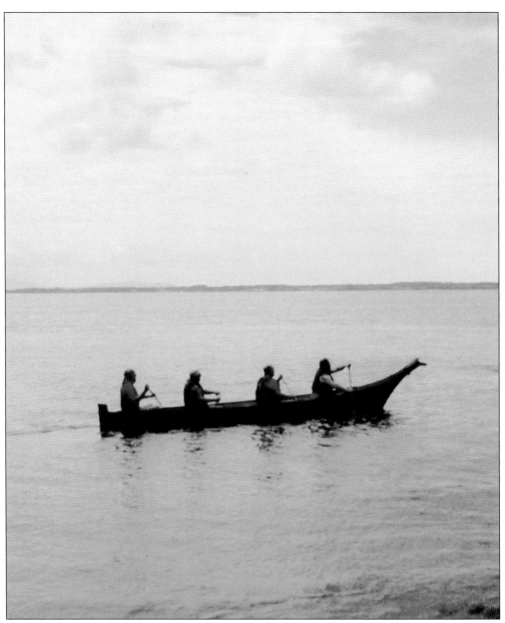

CANOE INDIANS. The Chinook Indians were consummate boatmen. They traveled in their sturdy dugout canoes on river, bay, and ocean, and in all kinds of weather. In their journals, explorers Meriwether Lewis and William Clark had described the Chinook canoes in detail, and a half century later, during his stay on Shoalwater Bay from 1852 to 1855, James Swan also wrote extensively about his Indian neighbors and of their prowess on the water. Though Espy and Clark had no such boating expertise, they were nonetheless optimistic and determined. When they reached the head of the bay and could not find the boat that Espy had cached away the preceding winter, they were undeterred. Looking for a solution to their transportation problem, they came upon a Chinook cemetery, where, according to Chinook tradition, the dead had been placed in canoes that were then hoisted up into the trees. Finding a craft that was not in use, they appropriated it and headed for *tsako-te-hahsh-eetl*. (James R. Sayce.)

HEARING A SIGN. By noon, Espy and Clark were past the north end of Long Island in their borrowed canoe with three-quarters of their trip behind them. At that point, however, the tide began to flood. The rising water brought with it a smoky nor'wester, loaded with rain and as thick as the heaviest fog. The men soon became disoriented and could only guess where they were headed—east, west, or even north toward the treacherous ocean bar. According to a later account by Espy, they began to pray for a sign by which they could save themselves. Just then they heard a rhythmic booming to their port side and hastened toward it. There they found Klickeas who, hearing the awkward paddling of the two men, had begun pounding on a hollow stump to guide them ashore. (Sydney Stevens.)

ACRES OF TINY SHELLFISH. The next morning Klickeas led Espy and Clark to the tideflats. There, stretching north and south as far as the eye could see, were acres of the tiny Native oysters, "often united in clumps that a boot could kick apart," Espy later remarked. Within a few days, the two young men began cutting alders and, with assistance from the Chinooks, built a 10-by-12-foot cabin not far from the salt marsh where Klickeas had drummed them ashore. Espy would go on to make his fortune in the oyster trade, while Clark set about platting the town that would become Oysterville and soon opened its first general merchandise store. (Alan Trimble.)

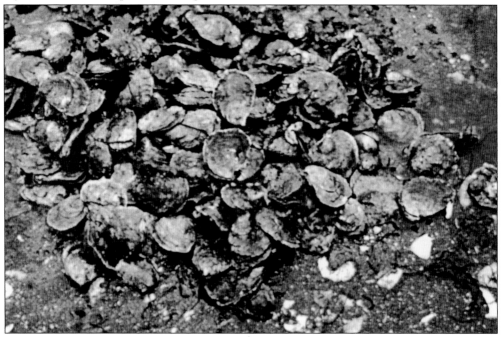

Two

BOOM

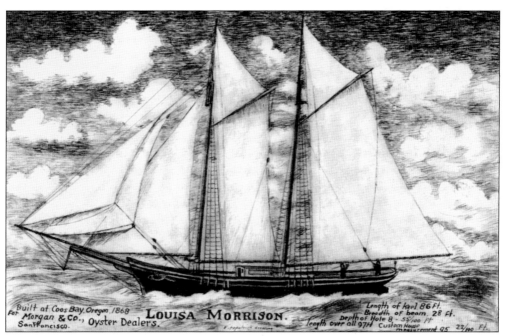

Built at Coos Bay, Oregon, 1868
For Morgan & Co., Oyster Dealers. **LOUISA MORRISON.**
San Francisco.
Length of keel 86 Ft.
Breadth of beam. 28 ft.
Depth of Hole 8 - 55/100 Ft
Length over all 97th Custom House
measurement 95 22/100 Ft.

CALIFORNIA CONNECTION. Soon, oyster schooners from San Francisco arrived in Shoalwater Bay at the rate of two or three a week. They carried as ballast building materials, livestock, furniture, barrels of liquor, and everything imaginable, from top hats to prostitutes. As soon as the incoming freight was off-loaded, bushel baskets of oysters were stowed aboard, and the ship captains headed out on the next tide with their precious cargoes. (Tucker Wachsmuth.)

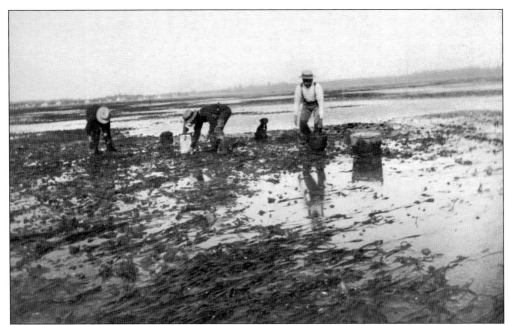

GATHERING OYSTERS. Between schooner arrivals, oystermen and their Chinook Indian employees gathered and transported oysters to cull beds, areas near shore that had been set aside for separating the oysters according to size and condition. There, bushel baskets were filled with the largest and best for the San Francisco market. Oysters were paid for in gold, $1 a bushel, upon delivery to the schooners. According to early area resident James Swan, the craft employed in the oyster trade in Shoalwater Bay in 1855 were: one 20-ton schooner, capacity 600 bushel baskets of oysters; 24 boats, total capacity 2,200 baskets; 21 scows, total capacity 1,980 baskets; and 13 canoes, total capacity 670 baskets. At first, oysters were gathered only when exposed during low tides (pictured above.) It was not long, however, before oyster tongs were developed. (D&L.)

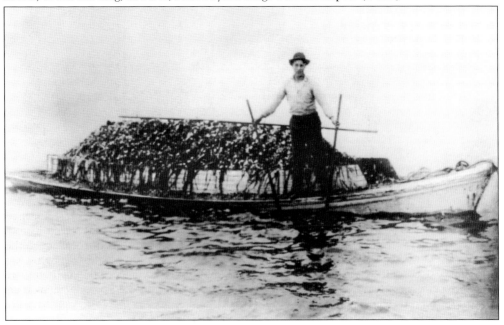

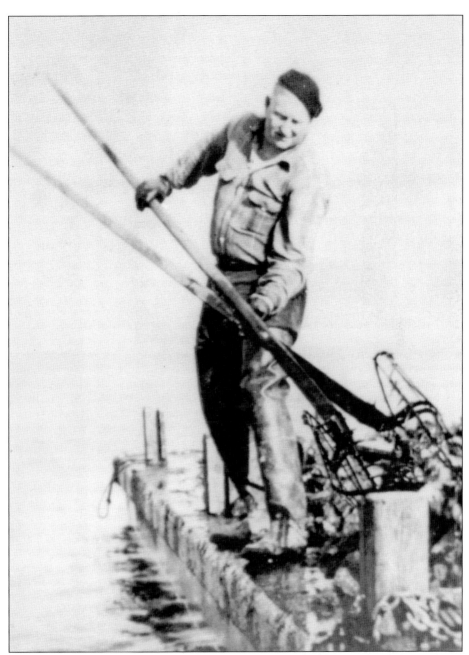

THE ART OF TONGING. Oyster tongs consisted of two long handles scissoring on a brass pin with tines at the ends that came together like teeth. From 12 to 20 feet in length, they could be used to gather oysters when the water was too deep for handpicking. Standing at the edge of a bateau, the oysterman lowered the tongs to the bay bottom, felt for the oysters, opened and closed the tongs to trap the shells, then lifted them and dropped the oysters onto the boat. Tonging was hard, slow work requiring strength and skill. Generally it took two men, working on opposite sides of the bateau, one to two tides to gather a full load. Oyster tongs were used for many years on the bay and were adapted according to the type of oysters being harvested. Shown above are tongs used in the 20th century for the large Pacific oysters. (EFC.)

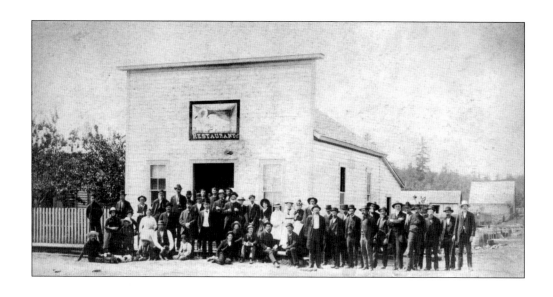

BOOM TOWN ON THE BAY. News of the Shoalwater Bay oyster discovery traveled fast, and in Oysterville, saloons and boardinghouses sprang up to accommodate the rapid influx of fortune-seeking men. Initially oyster beds were held by squatter's rights, but soon the Territorial Legislature realized that tideflats, like uplands, could be sold and taxed. H. S. Gile surveyed the tidelands, setting aside an 8-acre tract as a schooner bed, where ships could anchor while off-loading and loading. The remaining tidelands were divided into 5-acre parcels, called "whacks," which were distributed by lottery, and a rule was made that a man had to live in Oysterville for six months before he could begin oystering. In 1860, newcomer John Marshall complained in a letter home: "I allways thot [sic] the United States was a free country until now." (Above, EFC; below, Tucker Wachsmuth.)

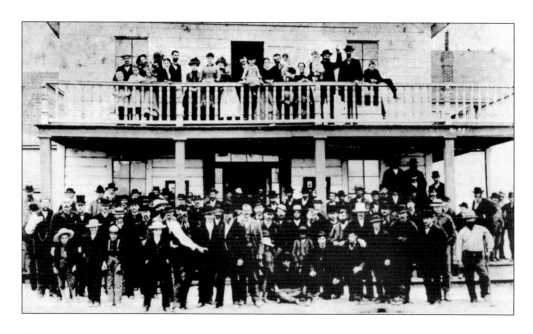

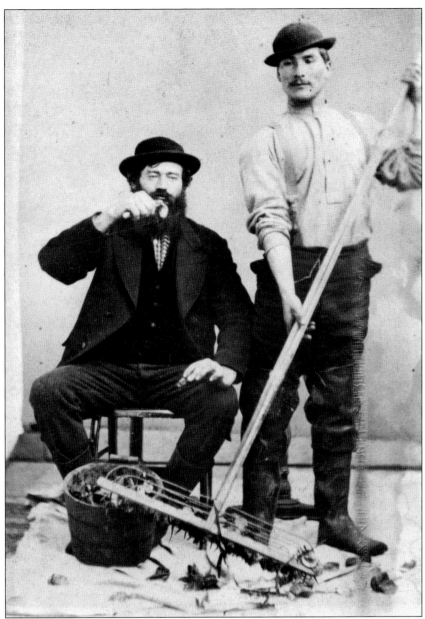

A SENSE OF PRIDE. Representative of the hardworking, fun-loving oystermen were Abe Wing, seen here eating an oyster on the half shell, and Capt. James R. Johnson Jr., who is displaying a pair of Native oyster tongs. Wing, like many of the early arrivals, came with other family members. His aunt Elvira Stevens was the first white woman to arrive in Oysterville, in 1854, with her husband, Gilbert. She is credited with naming the new settlement, and she and her husband built and managed the first hotel in town. "Captain Jimmy," as Johnson was called, ran the mail boat and was considered one of the best sailors on the bay. Tragically, in 1889, he was drowned in a freak accident while helping a neighbor transport lumber. He left his wife, Jane Haguet Johnson, and seven children, and when Myrtle, the eighth child, was born a few months later, Quinault and Chinook Indians arrived in their high prow canoes to honor this infant descendent of tribal chiefs. She was known as the last princess of Oysterville. (EFC.)

Pacific County Seat. Oysterville was little more than a year old in May 1855 when the Pacific County seat was moved from Chinookville on the Columbia River to the booming settlement on the western shore of Shoalwater Bay. Initially county commissioners met in rented hotel, store, or hall spaces, often leased from R. H. Espy or Andrew Wirt. In 1857, Joel Munson's store, now known as "the Red Cottage," was rented for use as a courthouse until 1868, when the county purchased it for $200. In addition to its 17-year use as the county courthouse, the building is remembered as the summer residence, from 1976 to 1996, of one of Oysterville's favorite sons, author Willard R. Espy. (EFC)

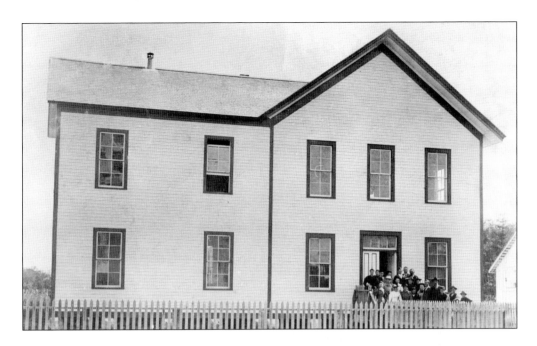

First Tax-Financed Building. In 1874, the Oysterville Courthouse was built by master carpenter John Peter Paul. It was the first tax-financed building in Pacific County, and according to the November 2, 1874, commissioners' minutes, the sum of $1,526 in gold coin was appropriated for its construction. The building had two rooms on the lower floor for county officials and a courtroom on the upper floor. An annex (pictured above, at left) was added later, and in 1875, a jail was built nearby. Until that time, transgressions had been generally overlooked by the citizens in the rowdy little town by the bay; those who clearly needed to be locked up were held in whatever room, house, or public building could be secured. (Above, Tucker Wachsmuth; below, CPHM.)

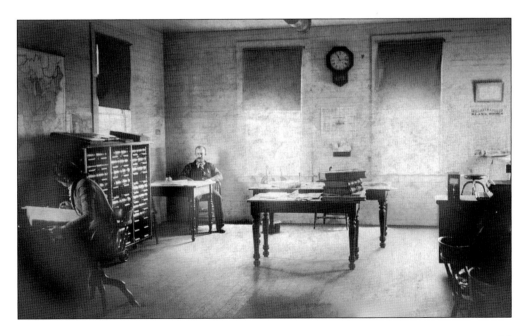

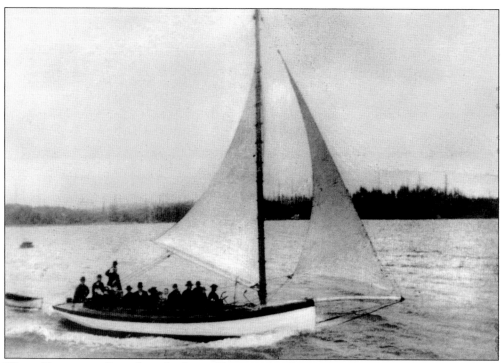

WATER TRANSPORT. Since the upland varied between treacherous swamps and virtually impenetrable forests, roads of any consequence were slow in making an appearance. White settlers traveled primarily by water, following the example of the local Chinooks and, at first, used Indian dugout canoes. Oyster schooners brought some rowboats and small sailboats, but soon oystermen were building their own craft, sometimes rigged with sails. When the time came to harvest oysters, skiffs, sloops, and small schooners dotted the water. If the oyster beds were far away from home, a round trip could take 24 hours or more. Of necessity, the oystermen added small deckhouses holding one or two bunks, and though they brought food prepared at home, galleys with small stoves were installed for making coffee and providing warmth. (D&L.)

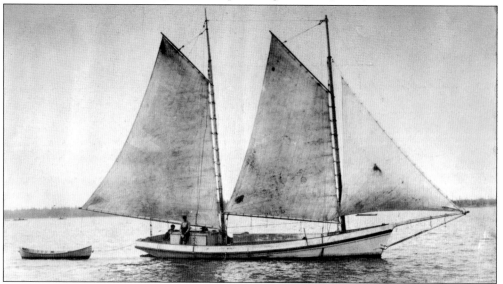

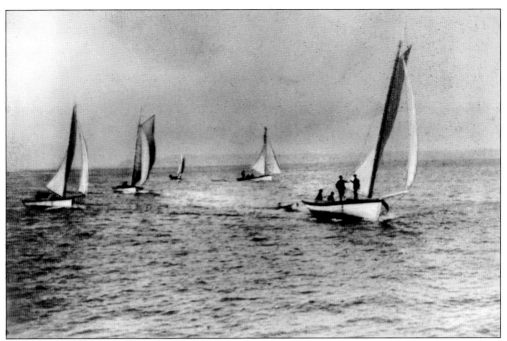

THE PLUNGER FLEET. In time, sloops, locally called "plungers" for their ability to plunge through the bay in all kinds of weather, were designed especially for use in the shallow tidewaters. These were sailboats with a jib, a mainsail, and a centerboard. They were built of material on hand, usually of spruce or fir, and were 10 feet wide and up to 30 feet long. The moveable centerboard made plungers especially useful in navigating shallow bay waters that were less accessible to boats with a fixed keel, allowing oystermen to easily reach their underwater beds in order to pick up loads of oysters and bring them ashore for processing. (Above, D&L; below, Dobby Wiegardt.)

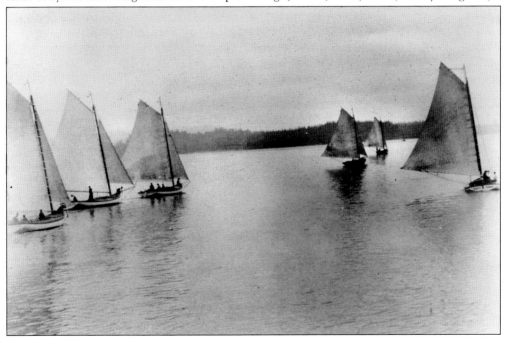

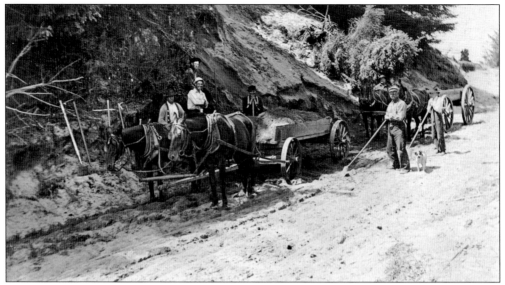

THE FIRST ROAD. In 1855, a road was built connecting Oysterville with the ocean beach, a short mile away. The route included two steep climbs—Davis Hill and the primary ocean dune. Both were formidable enough in good weather but were muddy stop-and-go obstacles when it was stormy. Nevertheless, "the mail must go!," and Isaac Whealdon of Ilwaco assured that it did. He carried mail and passengers the length of the peninsula by wagon three times a week, with the major portion of the route being along the hard-packed beach sands. It was said that the beach driver needed to be a first-class navigator, able to avoid the hazardous drift logs being carried back and forth in the swells during high tides and stormy weather. (Above, Charlotte Jacobs; below, EFC.)

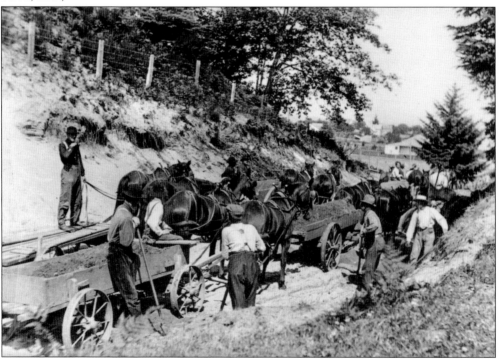

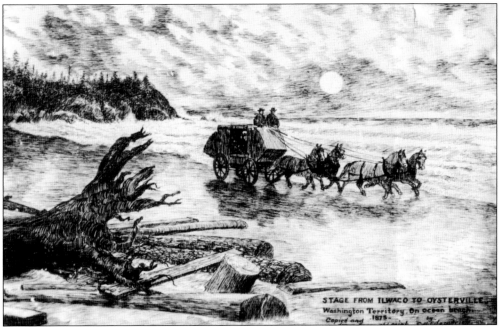

STAGE ALONG THE WEATHERBEACH. As Oysterville's population increased, a stagecoach replaced the wagon for the run along the peninsula's "weatherbeach," as the ocean shoreline was called. According to early driver John Morehead, "The stage was a primitive affair, resembling a prairie schooner with both ends closed and an entrance on either side. At the back was a strongly built 'boot' used for the purpose of carrying freight and baggage. There were five seats upon which 14 passengers could be uncomfortably carried but as no one was ever intentionally left, there was always room for one more, and sometimes more than twenty passengers were crowded on. The driver's seat was perched on the outside where it had no protection whatever, from the storms. There were no springs either under the seats or the body of the stage." (EFC.)

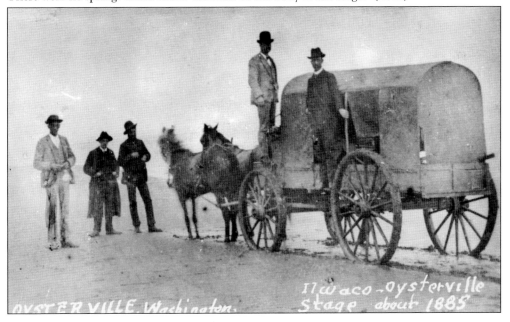

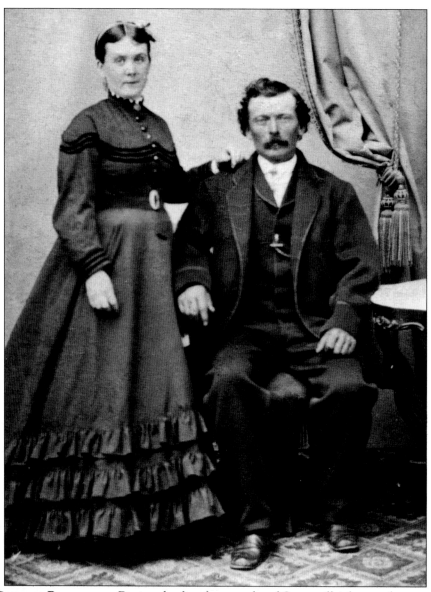

THE GROWING POPULATION. During the first few months of Oysterville's boom, the population consisted primarily of men. Many had come from the eastern states by way of the California gold fields. They were men intent upon striking it rich—if not by gold, then by oysters. Like Meinert Wachsmuth, pictured with his bride Elizabeth Sullivan Wachsmuth, those who found the work and the surroundings to their liking soon sent for their wives and families, determined to carve a life for themselves from the bountiful wilderness of Shoalwater Country. By the 1860 census, Oysterville had 210 permanent residents, among them 34 women and 61 children under the age of 18. Although occupations of the men included cooper, carpenter, mason, surveyor, blacksmith, tailor, teacher, physician, and farmer, the preponderance were listed as oystermen. They had made their way from far-flung regions, including Sweden, England, Ireland, Scotland, Canada, and 18 of the established 33 U.S. states. As families settled in, makeshift buildings were replaced by more substantial structures, and the little community on the bay began to take on an air of permanence. (Tucker Wachsmuth.)

Three

PROSPERITY

FIFTY DOLLARS A PLATE. In the 1860s, a plate of oysters in San Francisco cost two and a half $20 gold pieces. The high price and high demand for the tasty Shoalwater Bay bivalves rocketed Oysterville into prosperity. In the 1940s, Louis Wachsmuth, owner of Dan and Louis' Oyster Bar in Portland, Oregon, replicated what such a plate of oysters might have looked like. (D&L.)

TWO HOUSES, ONE PLAN. Brothers John and Tom Crellin came to Oysterville from the Isle of Man and brought with them their building plan—the same plan to be used by each of them. John built first, in 1867. Like most of the early houses in town, John's was constructed of redwood lumber milled in California and shipped north as ballast on an oyster schooner. This was easier, and perhaps cheaper, than using local materials, as there was not yet a mill on the west side of the bay. When Tom built his house two years later, he used the same plans but added bay windows and made all his rooms a little larger. Both houses were built facing the bay, the center of the town's activities. (Sydney Stevens.)

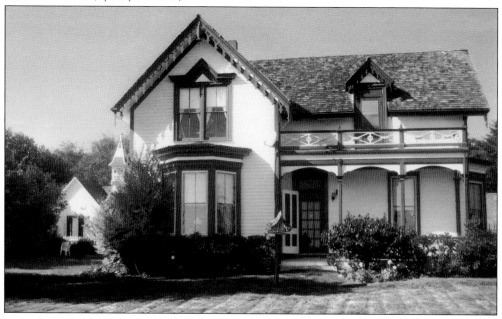

THE IRONY OF FATE. To prepare for their house-building projects, the Crellin brothers applied for land grants that, because Washington was still a territory and not yet a state, needed to be registered in Washington, D.C. John was first to send in his application, and President Lincoln, overworked with the burdens of the Civil War, stacked it on his desk for later attention. Soon younger brother, Tom, sent his application, and it, too, went on the evergrowing "to do" pile. As the war wound down, Lincoln began attending to his paperwork, and on April 1, 1865, just two weeks before his assassination, he signed Tom Crellin's certificate. It was not until September 15, 1866, that Pres. Andrew Johnson signed the certificate belonging to John. (Above, HKF; below, EFC.)

SCHOOL DISTRICT NO. 1. In 1869, school board members R. H. Espy and Lewis Loomis journeyed to Salem University (now Willamette University) in Oregon to interview for a schoolteacher. Six years previously, the first school building had been erected in Oysterville—a prefabricated building made of redwood sawn in California and shipped north on an oyster schooner. It consisted of one 18-by-30-foot room with teacher's desk and recitation table in the center. Two wide boards, nailed to opposite walls and extending the length of the room, served as student desks. Pupils sat with their backs to the teacher, boys facing one wall, girls the other. Hiring teachers in the remote village was difficult, hence the journey to Salem. Espy and Loomis, according to local lore, chose the prettiest candidate for the position, Miss Julia Jefferson. She proved satisfactory, but Espy and Loomis had to repeat the interviewing process the following year because, in the summer of 1870, Miss Julia became Espy's bride. And, of course, married women did not teach school! (EFC.)

R. H. Espy House. Built the year after his marriage, this was Espy's third home in Oysterville. It was certainly more commodious than the first log cabin he had shared with Clark and, presumably, was larger than his second home, of which there is no record. The house easily accommodated the Espys and their eight children, as well as friends and family who often lived with them for many months or even years at a time. Like most houses in town, it faced the bay, though the center of activity in the busy household occurred toward the back of the house (shown below), where the woodshed, laundry room, meat-hanging shed, and other work areas were located. (Sydney Stevens.)

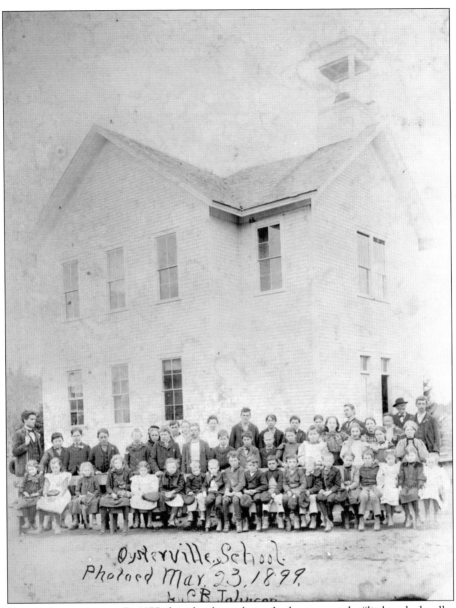

Oysterville School
Photoed May 23, 1899.
by C B Johnson

THE SECOND SCHOOLHOUSE. By 1875, the school population had outgrown the "little red schoolhouse," as the school built of California redwood was called. John Peter Paul was commissioned to draft plans and construct a new, larger building—the first publicly financed school building in Pacific County. It was built on a block of land donated by Gilbert Stevens "for school purposes." The two-story building, measuring approximately 40 by 40 feet, consisted of two rooms, one above the other. Students in the first four grades were taught on the lower floor; fifth through eighth grade students were taught upstairs. At first, the school operated for a three-month term each year, as did the other schools in the county. When budgeted monies gave out, local families pitched in toward the teacher's salary for an additional period of time. This was referred to as "school by subscription." Education beyond the eighth grade was a luxury for Oysterville students. Some students were sent away to private schools, but for many youngsters, grammar school completion was considered "good enough," and they immediately joined the work force. (EFC.)

CHILDHOOD FUN. In general, children did not begin school until they were about eight years old. Some were taught the basics at home and could read, write, and cipher by the time their formal, academic education began. All children participated in the work required to maintain the household, learning as they worked alongside parents or older siblings. Gardens were weeded, water pumped, wood chopped, and cows milked. Girls began to sew and cook at an early age, and boys accompanied fathers and brothers on hunting expeditions and fishing trips. Even though children were expected to do their share, there was still plenty of time for fun, and even some chores, especially seasonal ones such as berry-picking, were scarcely considered work. Recreation and entertainment centered on family, friends, and neighbors, and took place close to home. Dances, taffy-pulls, and school programs often involved the entire community and were eagerly anticipated. And, in the peaceful village of Oysterville, the woods, the bay, and the nearby grassy meadows always called out for "an explore." (EFC.)

SMALL HOUSES. The Charles Nelson house (pictured above) and the Capt. A. J. Stream house (below) were typical of many homes built during Oysterville's first decades. Both were small and solidly built, both boasted well-cared-for gardens, and both families held positions of respect within the community. Seven children were raised in the tiny, 384-square-foot Nelson home, and many Nelson descendents still live in the area. Stream, a decorated hero of the Life Saving Service, became a realtor when he retired. He moved across the bay about 1890, joining forces with other promoters who dreamed of making the little sawmill settlement of South Bend "the Baltimore of the Pacific." Within three years, their efforts had resulted in getting the bay's name changed to Willapa Bay and the county seat moved to South Bend, much to the distress of Oysterville's citizenry. (Nyel Stevens.)

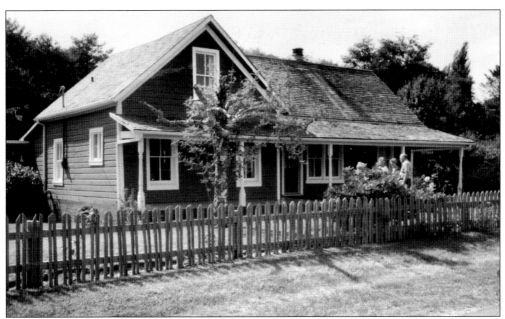

NEAR NEIGHBORS. W. D. Taylor built his house (pictured above) in 1870 while he was employed by Lewis Loomis as a stagecoach driver. Taylor and his wife, Adelaide, lived in the house for 16 years. During that time, Taylor also served as sheriff and assessor of Pacific County, and Adelaide was the community's midwife. In 1873, Swedish native Ned Osborn built his home (shown below) several lots to the south of the Taylors. As the house neared completion, Ned sent to the "Old Country" for his true love but learned that she had recently died. A somewhat different story is that when he was jilted by a local girl, Ned stopped working on his house. Either way, what is definitely known is that Ned lived in the house a bachelor until his death in 1906, never finishing the upstairs portion. (Sydney Stevens.)

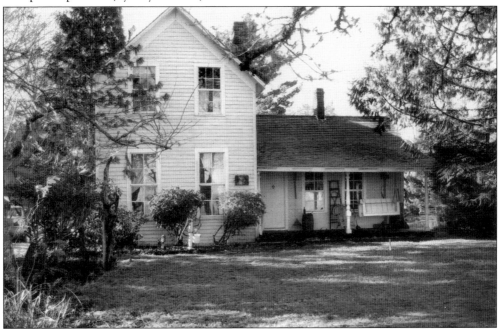

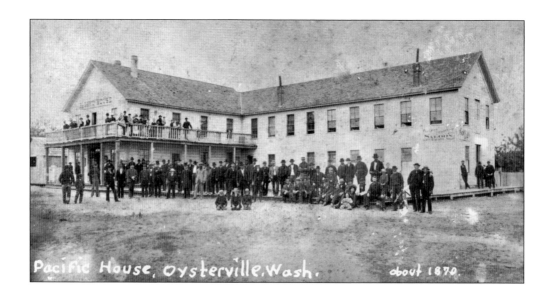

Pacific House, Oysterville, Wash. about 1870.

COURT CONNECTIONS. In 1870, Richard Carruthers built Pacific House, destined to become one of the best known hostelries in the Northwest. It was at the Pacific House that men congregated after being paid on the schooner bed, often drawing a line in the sand and pitching $20 gold pieces—closest without going over was the winner. When court was in session, the Carruthers family might serve as many as 250 meals a day. Not far south of the Pacific House was the home of Judge John Briscoe, who served as the area's fifth representative to the Territorial Legislature. In 1854, he was appointed probate judge by Gov. Isaac I. Stevens and was reelected to that position for some years. He and his wife, Julia, were highly respected members of the pioneer community. (Above, EFC; below, Charlotte Jacobs.)

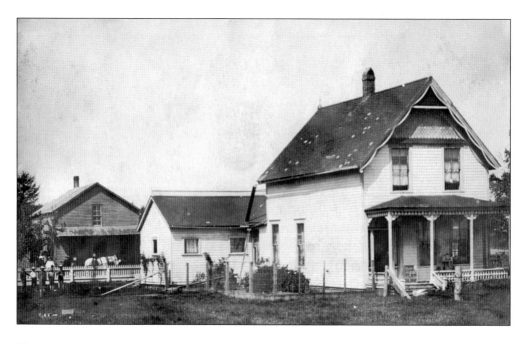

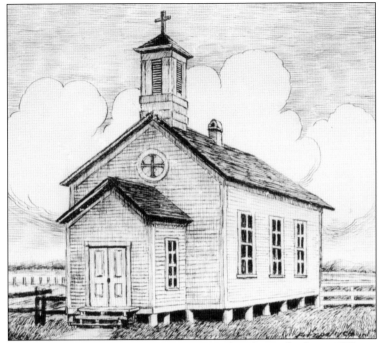

THE METHODIST CHURCH. Oysterville's Methodist Church was built in 1872; it was the first church in the county. On the corner of Pacific and Main Streets, its proximity to the town's two most popular saloons—Dan Rodway's across Pacific and Richard Carruthers's across Main—stuck in Dora Espy Wilson's mind when she told about growing up in Oysterville in the 1870s: "The Methodist Church across the street would hold revival services. Carruthers at the saloon would go to the service and get converted. People would go around saying how nice it was that Carruthers was saved. Then he would backslide again. As a kid I would wonder what God would do with him after he got him saved." The church blew down in a gale on January 29, 1921, its bell ringing eerily as the steeple toppled. (EFC.)

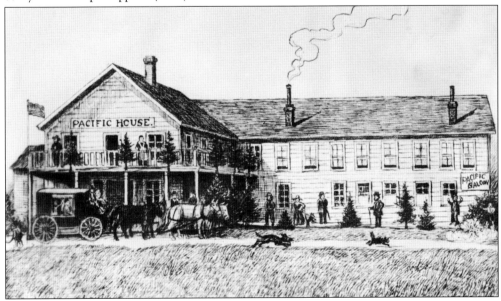

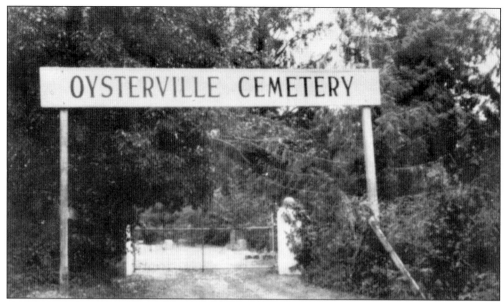

OYSTERVILLE CEMETERY. F. C. Davis sold an acre of land atop the hill west of town to the Oysterville Cemetery Association in 1890, though the town's burial ground had been located there since 1860. The delay in formalities probably had not bothered Davis in the slightest. He was a God-fearing, community-spirited man who labored hard for Oysterville, Pacific County, and Washington Territory. A Seventh Day Baptist, he did not work on Saturdays, though he worked any other time and overtime, as well. One of his many jobs was to take a team and wagon out on the tideflats when the oyster schooners came in, picking up freight for delivery to local stores. He adamantly refused to off-load barrels of whiskey, however, considering his hardworking red oxen, Moses and Aaron, "too noble" for such labor. (Above, Sydney Stevens; below, Charlotte Jacobs.)

HISTORICAL SIGNIFICANCE. The actual gravesites of John Douglas and Chief Nahcati are uncertain—they may not be located in the Oysterville Cemetery. However, in the mid-20th century, several descendents of pioneers felt that both men should be memorialized at the cemetery and that their "graves" should be included on cemetery lists and map. Douglas, a cooper on a whaling vessel, settled in 1846 on his Donation Land Claim immediately south of what would become Oysterville—the first permanent American settler on Shoalwater Bay. Meanwhile, Nahcati and his family wintered several miles farther south; the town of Nahcotta is named after him. Perhaps because he was about their age and soon befriended them, Nahcati is often (mistakenly) credited with guiding Espy and Clark to the area. (Sydney Stevens.)

1875

Built 1875

A. Wirt Oyster Sloop.
1890

HISTORIC OYS

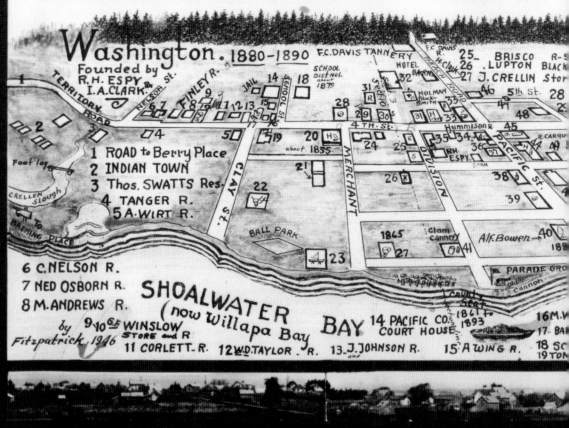

Washington. 1880-1890
Founded by
R.H. ESPY &
I.A. CLARK

F.C.DAVIS TANNERY
SCHOOL DIST.No.1 about 1879
F.C. DAVIS HOTEL
25. BRISCO R-S
26. LUPTON BLACK
27. J. CRELLIN Stor
28

1 ROAD to Berry Place
2 INDIAN TOWN
3 Thos. SWATTS Res.
4 TANGER R.
5 A. WIRT R.

about 1855

BALL PARK

6 C.NELSON R.
7 NED OSBORN R.
8 M. ANDREWS R.
by Fitzpatrick 1946 9 10 Gⁱ WINSLOW STORE and R
11 CORLETT R. 12 W.D. TAYLOR R. 13 J. JOHNSON R.

SHOALWATER
(now Willapa Bay) BAY

14 PACIFIC CO.
COURT HOUSE
County Seat 1861 to 1893

15 A. WING R.

16 M. W.
17 BA
18 SC
19 TON

1865 Clam Cannery Alf. Bowen → 40
188

PARADE GRO

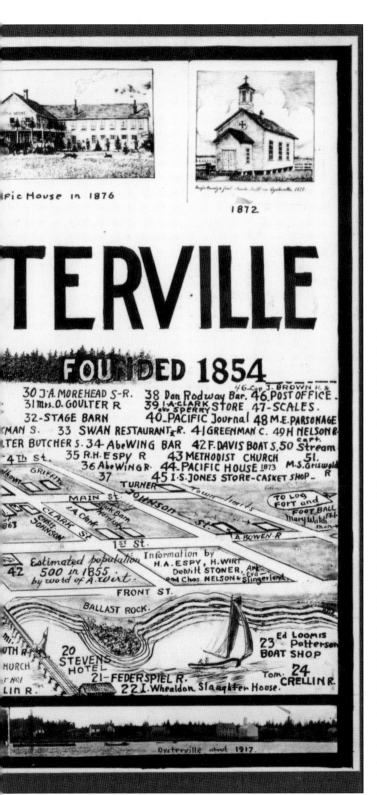

ific House in 1876

1872

TERVILLE

FOUNDED 1854

30 J. A. MOREHEAD S-R. 38 Dan Rodway Bar. 46. POST OFFICE.
31 Mrs. O. GOULTER R 39 I. A. CLARK STORE 47-SCALES.
 Abe SPERRY
32-STAGE BARN 40. PACIFIC Journal 48 M.E. PARSONAGE
MAN S. 33 SWAN RESTAURANT x-R. 41 GREENMAN C. 49 H NELSON R.
TER BUTCHER S. 34 Abe WING BAR 42 F. DAVIS BOAT S. 50 Stream
4th St. 35 R.H. ESPY R 43 METHODIST CHURCH 51.
 36 Abe WING R. 44. PACIFIC HOUSE 1873 M.S. Griswold
 37 45 I.S. JONES STORE-CASKET SHOP. R
46. Cap. J. BROWN R &

Estimated population
500 in 1855
by word of A. Wirt.

Information by
H.A. ESPY, H. WIRT
DeWitt STONER, Ark
and Chas. NELSON + Slingerland

TO Log
FORT and
FOOT BALL
Mary Waldi

TURNER
MAIN St.
JOHNSON St.
1st St.
FRONT St.
BALLAST ROCK.

GRIFFITH
CLARK St.
CHRIS JOHNSON
I.A. Clark
Clark Barn Hardware
A. BOWEN-R

Ed Loomis
23 Patterson
BOAT SHOP

20 STEVENS HOTEL
21-FEDERSPIEL R.
22 I. Whealdon Slaughter House.

Tom 24
CRELLIN R.

Oysterville about 1917.

HISTORIC MAP. In the mid-20th century, some of Oysterville's old-timers fashioned a composite map noting locations of businesses, residences, public buildings, and landmarks of the town's glory days. They pointed out that not all the features had been there simultaneously, and some, by then, existed only in memory. The fort, for instance, located at the extreme north end of town, was started (but never finished) in 1855 by the Oysterville members of the Pacific County Regiment of Militia of Washington Territory. For most of a century, its only remembrance was through R. H. Espy's honorary designation as "Major," the title by which he was known until his death in 1918. Also gone was "Indian Town" to the south, which had been built by early oyster companies to entice Indian workers to live full-time, rather than seasonally, in Oysterville. (D&L.)

MORGAN OYSTER COMPANY. In 1860, brothers John and Tom Crellin formed a partnership with John Morgan, one of the original Bruce Boys. In Oysterville, John Crellin (left) managed the operation on the oyster grounds while Tom (below) ran a store and oversaw the oyster shipping. Morgan, based in San Francisco, handled sales at that end of the business. By then, Shoalwater Bay was the principal source of fresh oysters for California, supplying 90 percent of the oysters received in San Francisco, where the industry was known as the "Shoalwater Bay Trade." On arrival from Washington, some oysters went immediately into wholesale and retail markets; the remainder were laid out on beds in San Francisco Bay, where they remained fresh until needed. (Above, Whipple Manning family; below, EFC.)

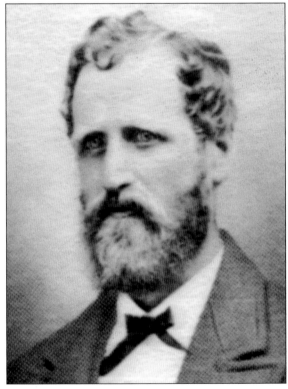

PEAK OF PROSPERITY. With the 1870s came the peak years of Oysterville's prosperity. Dominating village life was the oyster industry, and dominating the oyster industry in Oysterville were a handful of men, including Major Espy, the Crellin brothers, Meinert Wachsmuth, Ed Loomis, M. S. Griswold, and Hiram Wing. Many partnerships and companies formed and re-formed, and often, serious rivals later joined forces with one another. Since there was no packing industry in the Shoalwater region, oysters continued to be shipped in the shell in 100-pound sacks or in baskets holding 32 pounds. Schooners could carry from 1,000 to 2,000 bushels, but greed overcame some early shipmasters, who tried to take as many as 4,000 bushels at one sailing. Oysters in the bottom of the hold smothered and spoiled by the time the ship completed the four- to six-day voyage to San Francisco. (D&L.)

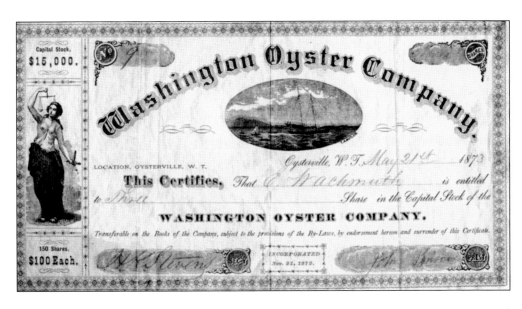

45

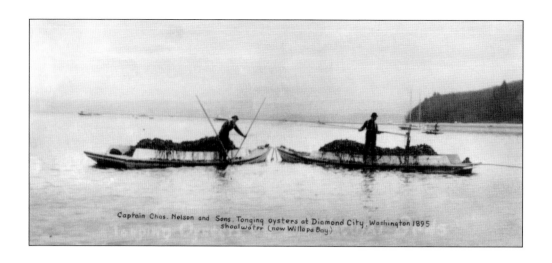

Captain Chas. Nelson and Sons. Tonging oysters at Diamond City. Washington 1895 shoalwater (now Willapa Bay)

THE NATURAL BEDS. In 1873, the Territorial Legislature, attempting to rebuild the diminishing supply of Native oysters, passed an Act to Encourage the Cultivation of Oysters. It allowed any individual to use up to 20 acres for planting oysters where there were no natural beds. The natural beds belonged to the residents of the Territory of Washington and could not be sold. Large sections were set aside as "State Oyster Reserves," from which, at designated times, oysters could be purchased for replanting on private ground. Oysters were tonged onto flat-bottomed bateaux, a popular craft copied from French oystermen. Bateaux, each measuring about 20 by 60 feet and pointed at one end, were towed by sailboats or propelled by sculling or by pushing long poles against the shallow bay bottom. (Above, D&L; below, Dobby Wiegardt.)

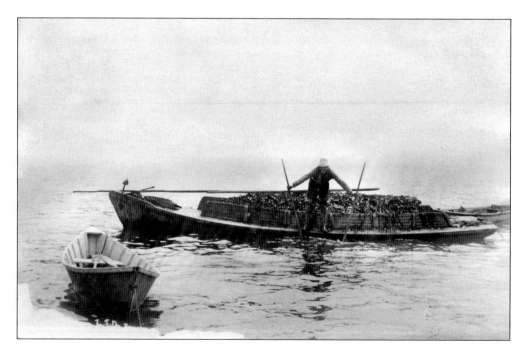

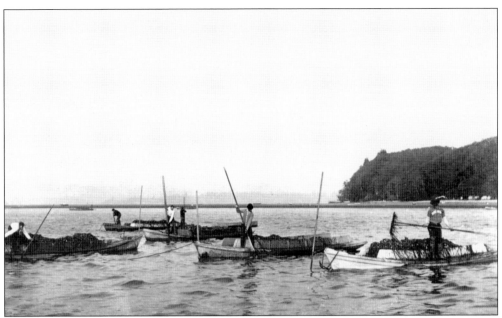

STATE RESERVES. The "reserve season" was a colorful period each spring when sloops and plungers paraded the bay towing strings of bateaux and dinghies. This was the time set by the state when growers could gather crews and equipment to tong small seed oysters from the state reserves and transfer them onto their private oyster beds. Oysters then needed two to three years' growth until they were of harvestable size, ready to cull. During culling, the large oysters were put on a "float," where they could be kept up to a month awaiting market. A float was essentially a floating floor that was constructed so that oysters placed on it stayed under water. The craft shown below was known as "Clark's Float" but was more likely a moveable culling house, not a true float. (Above, PCHS; below, Tucker Wachsmuth.)

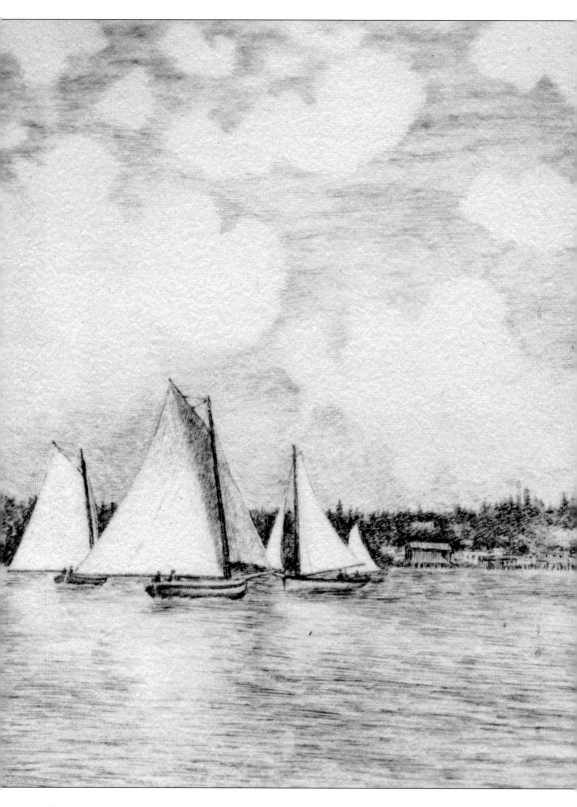

THE ANNUAL REGATTA. In the early 1870s, the Shoalwater Bay Yacht Club was organized, with its headquarters at Oysterville. Annual regattas were held to see which of the graceful plungers could sail a 30-mile, triangular course in the shortest time. Seamanship, as well as skillful boat building, had much to do with the outcome. Almost every oysterman was a club member, and the annual races were greatly anticipated. Major Espy, acting as commodore of the day, opened the festivities wearing a beaver hat and a light linen duster, giving the order to fire the town cannon. Following the races, there was a Regatta Ball, remembered as the crowning social event of the season. In the year of the centennial, 1876, the steamer *Gussie Telfair* brought 250 Portlanders, a brass band, and a theatrical troupe to the occasion. (EFC.)

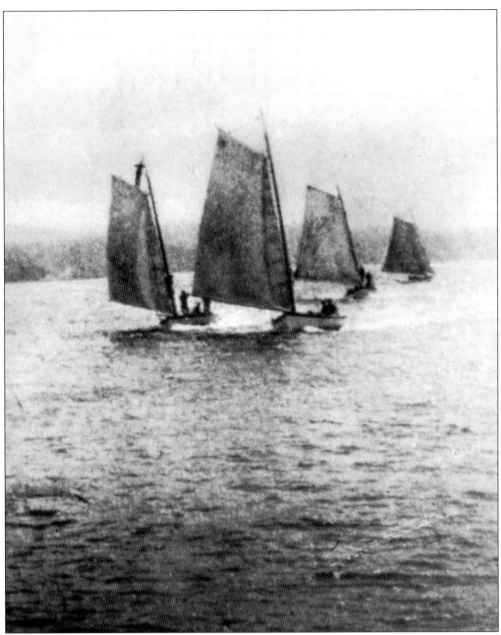

THE EXPERTS. Among the Oysterville men who were recognized as expert sailors in the early regattas were Ed Loomis, Tom Crellin, James Johnson, Captain Stream, Wes Whitcomb, and Charles Fisher. Prizes offered the winning crews were a silver cup for first place, a silver watch for second, and a gold-headed cane for third. Although the Shoalwater Bay Yacht Club disbanded in the late 1870s due to "dullness" of the oyster business, a second generation took up the sport a decade later. During that period of time, the Louderback Boat Works in South Bend built many legendary sloops, such as the *Sailor Boy, Pearl, Columbia, Undine,* and *Dauntless.* All of those boats won races at the Shoalwater Bay and Astoria regattas, but Wallace Stewart (aka Stuart), himself a winner of 17 Oysterville regattas, considered the *Dauntless* the fastest sloop ever built on the bay. (D&L.)

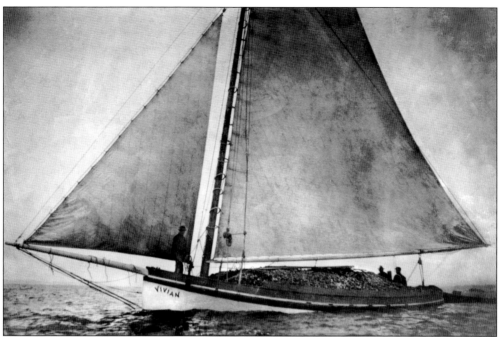

FAST, VERSATILE, RELIABLE. In addition to providing the fastest means of travel in Shoalwater Country, sloops such as the *Vivian* (above) and the *White Wings* (below) were versatile, as well. Not only did they serve as the backbone of the oyster fleet, they also were used for delivering freight and mail to the several ports on the bay. One shortcut across the tidelands went through a slough that is still called "Mailboat Slough." Besides saving several miles in transit, better wind was said to be available there. Nor were plungers only useful for practical matters, such as work. Moonlight boat sails on the bay were a favorite summer evening pastime of young swains and their sweethearts, the groups of young people always well-chaperoned, according to the memoir of early schoolteacher Bertha Allison. (D&L.)

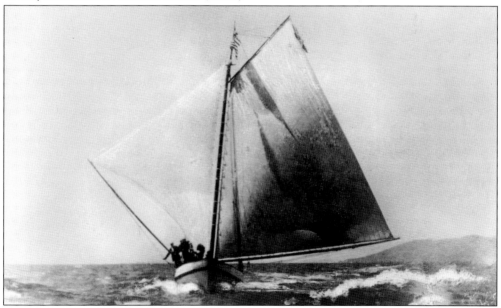

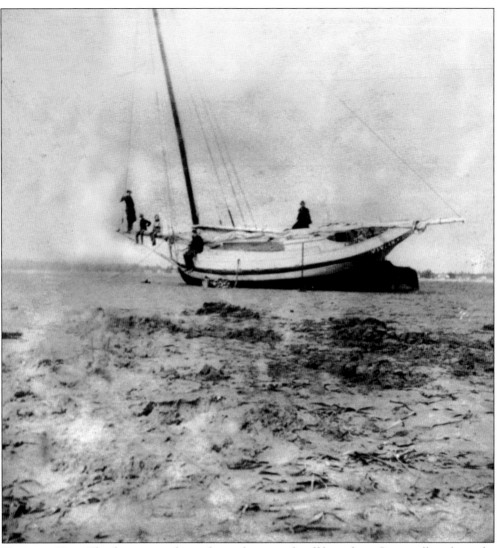

HIGH AND DRY. The deep-water channel was about a mile offshore from Oysterville at low tide, a long way to walk, especially if equipment or oysters had to be carried. Plungers were usually anchored a considerable distance from shore, and oystermen used small dinghies in getting ashore and back to their boats. Clyde Winslow, who lived in Oysterville at the turn of the 20th century, gave this account of a problem caused by the distant off-shore anchorage: "On our bay side during one violent winter storm, the West Coast Oyster Company plunger, *Vivian*, tore loose from her anchorage and shot off north before the gale. DeWitt Stoner and Anton Nelson put out in a dinghy trying to intercept her. They swamped and capsized in the high seas, and only the desperation try by a rescue party in another boat saved them from drowning. These were iron men, indeed. If ever they showed fear, I saw no signs of it in the years I was around Oysterville." (PCHS)

Four

DECLINE

A FORESHADOWING OF TROUBLE. On the night of January 1, 1875, the weather turned sharply cold, and the thermometer hovered at zero. When morning dawned, parts of the bay were sheets of solid ice, the oysters embedded within. As the tide moved in and then out, the oyster-laden ice simply floated out to sea, totally wiping out many beds. The freezing weather continued for eight long days and nights. (Tucker Wachsmuth.)

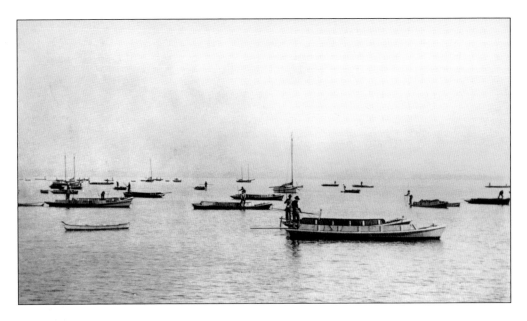

MORE WEATHER PROBLEMS. Although the industry recovered quickly from "the big freeze of 1875," and oystermen soon regained their annual production rate of 200,000 baskets, the following December a second weather event again caused havoc. On the beds, wind-driven waves washed oysters away completely or piled them into high ridges, causing the oysters at the bottom to suffocate. Despite these weather disasters, oystermen remained optimistic and, in 1884, built a half-mile-long dock at the north end of town. It was equipped with a track and sail car that could be used to get back and forth to the deeper water where their boats were anchored. When the bay again froze over in 1888, the dock was swept away by floating ice during the breakup of a spring thaw. The dock was never replaced. (Above, Dobby Wiegardt; below, D&L.)

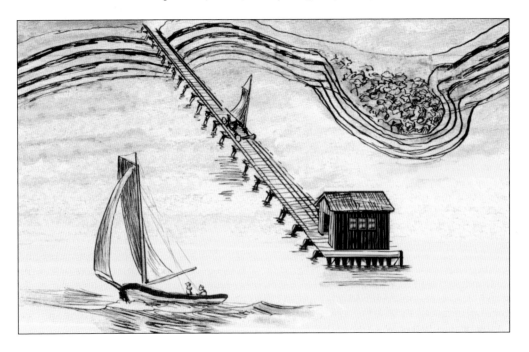

LIFE AS USUAL. Whatever the disasters on the tideflats, the women of the village maintained their resiliency and, above all, their standards. Harry Espy (1876–1958) told how, up to the age of seven or eight, he and his sister Dora had to accompany their mother twice a week in formal calls on their neighbors. "Mother made sure that I looked her—not my—best on these occasions. Dora would be ready, elegantly turned out . . . while my mother was still trying to entice me into what she called kilts but what I think of as a smock built like a double-breasted coat and coming to my knees. Generally it was an affair of blue-checked gingham, with trousers of the same material well hidden underneath. Once mother had decided I looked passable, she would spend an interminable time deciding which of her black gloves to wear, the kid or the silk. She alternated her calling schedule, covering the north end of town on one round and the south end on the next." (Tucker Wachsmuth.)

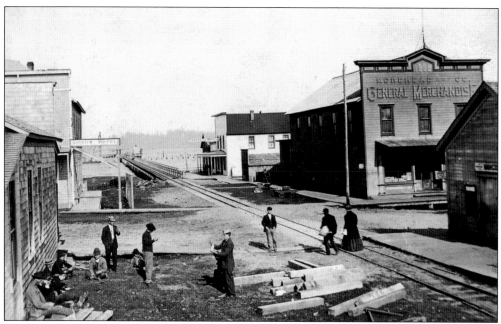

More Difficulties. Beginning in the mid-1880s, a series of setbacks befell Oysterville. First, the Native oyster population declined, probably through the overharvesting of the past 30 years. Annual production fell to 2,000 sacks per year, a tenth of what it had been during the decade just past. Then, in 1889, the new Ilwaco railway chose Nahcotta over Oysterville as its terminus. Not only did Oysterville oystermen feel cut off from rail access to distant markets, but the entire village was also distraught over the many businesses that moved to the newly created town. The final blow came in 1892 when the county electorate voted for South Bend as the new county seat, prompting "South Bend raiders" to make off with courthouse records. (Above, CPHM; below, TSF.)

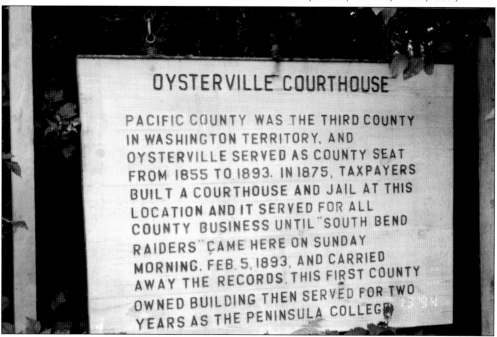

OYSTERVILLE COURTHOUSE

PACIFIC COUNTY WAS THE THIRD COUNTY
IN WASHINGTON TERRITORY, AND
OYSTERVILLE SERVED AS COUNTY SEAT
FROM 1855 TO 1893. IN 1875, TAXPAYERS
BUILT A COURTHOUSE AND JAIL AT THIS
LOCATION AND IT SERVED FOR ALL
COUNTY BUSINESS UNTIL "SOUTH BEND
RAIDERS" CAME HERE ON SUNDAY
MORNING, FEB. 5, 1893, AND CARRIED
AWAY THE RECORDS. THIS FIRST COUNTY
OWNED BUILDING THEN SERVED FOR TWO
YEARS AS THE PENINSULA COLLEGE

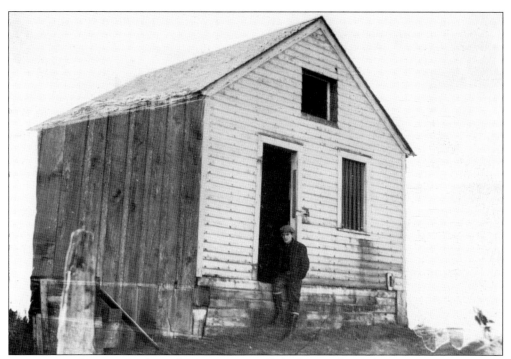

THEY LEFT IN DROVES. By the early 1890s, Oysterville had entered a "dull" period. With the oysters in decline, the transportation hub in Nahcotta, and the county seat now clear across the bay, there was little reason for most folks to stay in Oysterville, and the population rapidly decreased. Most businesses moved, for without the viability of a strong oyster industry, there was no need for the many ancillary jobs that had flourished during the boom years. Blacksmiths, sailmakers, hostellers, and many others moved away. For some, such as Alf Bowen, a newspaper publisher and editor, and John Morehead, a proprietor of one of the general stores, it was relatively easy to transfer interests 4 miles south to Nahcotta. Others just left, taking what they could manage and leaving everything else behind. (EFC.)

A SIMPLE, UNCOMPLICATED LIFE. A few of the pioneer families remained, content to lead a simple, uncomplicated life. Dewitt Stoner, who had arrived in 1884 as a boy of 11, later remembered, "I come here with my brother and his family. We lived in a house, a three-room house, right where the Baptist church stands now. The alder grove came right down to the house. Quite a number of times, my brother called his wife to get breakfast. Then he'd kill a deer in the alders, dress it and have it hanging outside the house by the time breakfast was ready. In them days we didn't have any meat problem. We just took a gun out and got it. . . . In them days if fellows wanted to hunt, there was no game laws and nobody killed anything but just what they wanted to eat . . . just like the Indians. There were all kinds of ducks and geese all winter. On a stormy day you could take your gun and get as many as you could use." (Tucker Wachsmuth.)

SUBSISTENCE FARMING. Those who stayed considered Oysterville a fine place to raise a family. Of necessity they became self-sufficient, growing a good portion of their own food and spending hard-to-come-by "cash money" only for items that they could not provide themselves. Every household had chickens, a cow, a vegetable garden, and a small orchard. Several local farmers raised beef, selling or bartering the meat. During summer and fall, women put up fruit, canned vegetables and meat, preserved eggs in water glass and, in general, laid by plenty to see their families through the long, dark days of winter. No one went hungry. As Willard Espy (1910–1999) said of his childhood, "I thought we were rich, but a special kind of rich. The kind without any money." (Tucker Wachsmuth.)

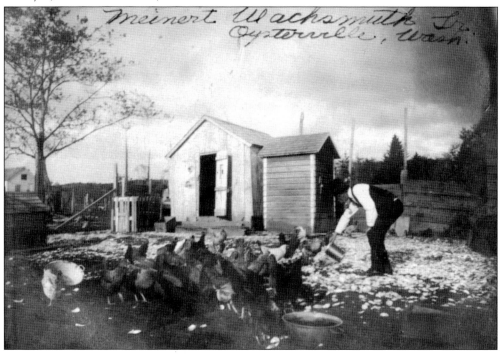

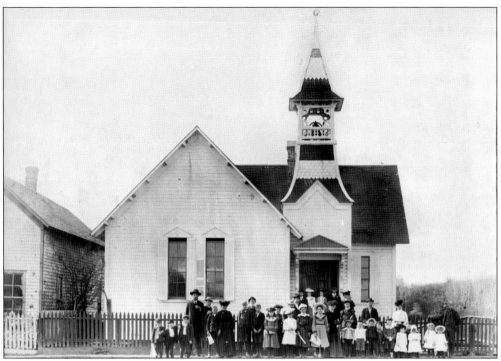

THE BAPTIST CHURCH. Although the Oysterville Baptists had organized in 1863, it was not until 1892 that they built their church. Until then, they had met at various homes—usually at R. H. Espy's—and baptized new members in the bay. Itinerant preachers who came to town stayed with the Espys as well. Indeed, one stayed for 12 years, his visit only terminated by his death. At the time the church was built, therefore, Espy bought the vacant Tom Crellin house across the street to be used as a parsonage. On the day of the church's dedication, the state-of-the-art baptismal font was filled by bucket brigade, baptisms were duly performed, and the discovery was made that the 3-foot-deep font had not been provided with a drain. Henceforth, it was back to the bay for baptisms! (EFC.)

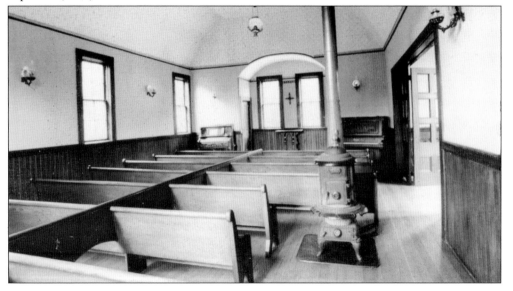

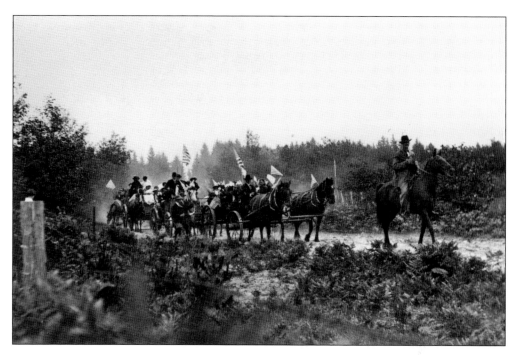

PATRIOTIC FUN. The citizens of Oysterville enjoyed a good celebration and took pride in their patriotism. Each Independence Day they dressed in their finery and lined up for the parade to the picnic grounds at Skating Lake. There, the dignitaries made speeches, contents of picnic baskets were shared, and after the music and traditional sing-along, the races began. Prizes ranged from $1 for the "horse race," to third place prizes of 25¢ for the "foot race for boys under 10" and for the "fat woman's race." Fifty cents was offered the winners of the "peanut race for boys and girls under eight" and for the "hop, step, and jump for men." The festivities concluded with evening fireworks at the waterfront. (Above, EFC; below, Charlotte Jacobs.)

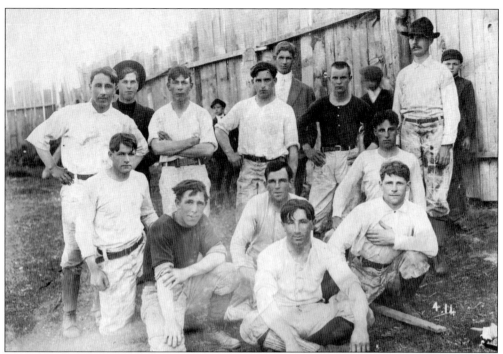

READIN', WRITIN', 'RITHMETIC, AND SOCCER. In Oysterville's early years, the school population included a motley assortment of students. When tides or weather precluded work, oystermen interested in improving their "booklarnin'" abilities often swelled the ranks of classes and sometimes made the teacher's job difficult. According to the memoir of Dr. Bethenia Owens Adair, one of the first teachers in the village, "The Oysterville School had the undesirable reputation of being ungovernable." But by the 1880s, school conditions had settled down to more acceptable standards. Students ranged in age from six to 14, the school year lasted from September through May, and the school day began at 9:00 a.m. and lasted until 3:30 p.m., leaving plenty of time for a game of soccer before heading home to evening chores. (Tucker Wachsmuth.)

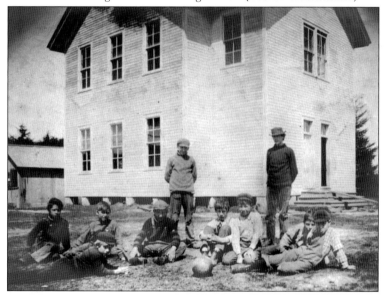

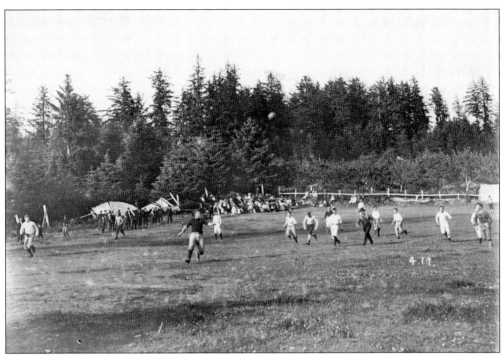

SPECTATOR SPORT. It is said that soccer was first introduced to the North Beach Peninsula in the 1880s by shipwrecked English sailors. Since wrecks were numerous during that time period and many involved English-speaking crews, such a circumstance is certainly possible. In fact, during the years from 1880 to 1885, eight British vessels wrecked near the Columbia River bar in the area known as "the graveyard of the Pacific." Three of those ships, the G. *Broughton*, the *Lammerlaw*, and the *Dewa Gungadgar*, actually came ashore near Leadbetter Point, just a few miles north of Oysterville. But no matter how the citizens of the village learned to play soccer, it is a certainty that players and spectators alike were enthusiastic about the game. (Tucker Wachsmuth.)

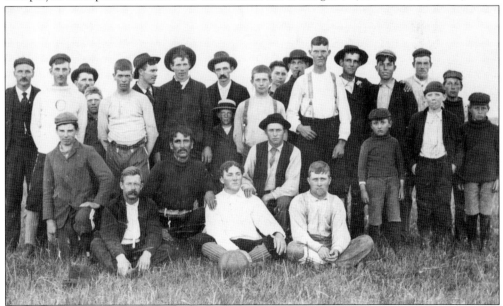

THE ROAD WEST. Variously called Pacific, Weatherbeach, or simply Beach Road, the road heading west out of town led directly to the ocean dunes and the vast Pacific. For the first 100 years of settlement, there was no sign of habitation at the road's end except for shore birds and the occasional black bear or black-tailed deer. Tufts of dune grass, beach verbena, and tiny wild strawberries braved the blowing sands of the ever-shifting dunes. The surf stretched endlessly north and south, tempting bathers, but cold temperatures and a treacherous undertow curtailed all but the bravest or the most fool-hardy. By the final decades of the 20th century, however, the new community of Surfside replaced Oysterville's dunes, and the peaceful vista at the end of Oysterville Road had forever changed. (Above, HKF; below, EFC.)

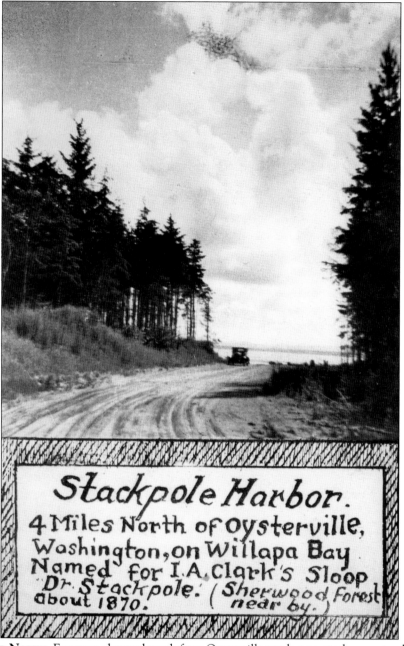

THE ROAD NORTH. For years, the road north from Oysterville was but a rutted wagon track ending at Leadbetter Point, where the bay and ocean meet. Originally called Low Point in 1788 by British explorer Capt. John Meares, the name was changed in 1852 to honor Lt. Danville Leadbetter of the U.S. Coast Survey. Gradually, the road has been surfaced, first with crushed oyster shell, then with gravel, and most recently with asphalt. With each new surfacing, the road was lengthened a bit to keep pace with the ever-growing sands of the peninsula. About 1 mile from the point is a small, protected cove, where Isaac Clark, a timid sailor, often waited out a squall in his little sailboat, *Dr. Stackpole*. To tease Clark, local oystermen called the spot Stackpole Harbor, and the name stuck. (EFC.)

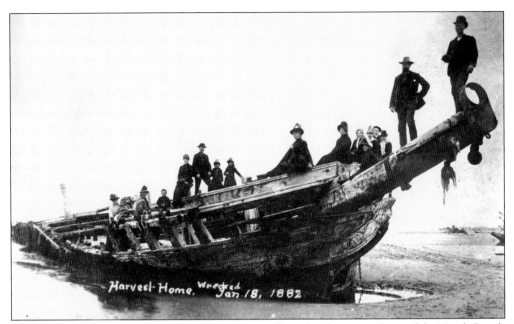

Harvest Home, Wrecked Jan 18, 1882

SHIPWRECKS. The fearsome cry "Ship Ashore!" was all too familiar to residents of the North Beach Peninsula. It was the signal for men to hurry to the beach with their wagons, extra blankets, perhaps a flask of brandy or hot coffee, and, if it was dark, their lanterns. Women readied medical supplies, dry clothing, hot meals, and beds for rescued crewmembers who might need to stay for a time. The county wreckmaster was sent for to protect the wreck and its cargo from "seagulls," a local term for those who helped themselves to whatever might litter the beach after a shipwreck. And, always, the curious gathered. "We didn't have any school after twelve o'clock because we wanted to go see the ship," wrote one Oysterville child. (Above, Tucker Wachsmuth; below, EFC.)

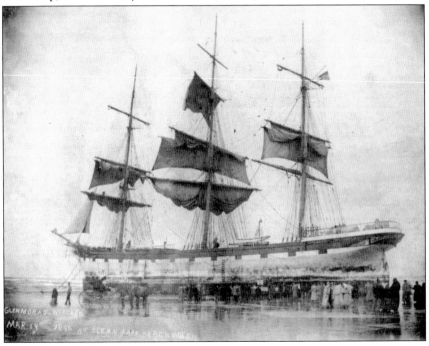

GLENMORAG, Wrecked MAR. 19 1896 AT OCEAN PARK BEACH

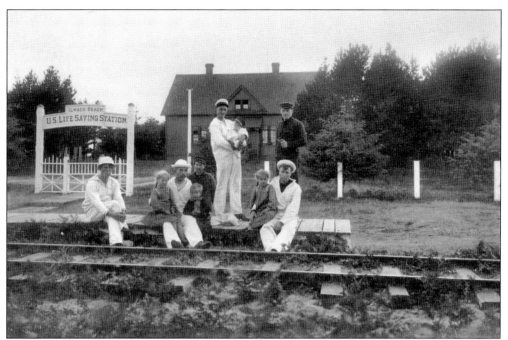

LIFE SAVING STATION. The Klipsan Beach Life Saving Station, first known as the Ilwaco Beach Station, was established in 1889. It was located on the ocean beach 14 miles north of Cape Disappointment and 12 miles south of the entrance to Shoalwater Bay. The crew was comprised of a captain and eight surfmen. The primary rescue equipment were surfboats, which were stored on four-wheeled wagons and pulled into the water by men or horses, then removed from the wagons and launched. The crew drilled regularly to improve their launch time, and spectators were welcome. A popular attraction of the Ilwaco Railroad's summer schedule was the weekly stop to watch the drills. In addition, vacationers from towns all along the beach came by horse and buggy, bicycle, and afoot to see the crew in action. (EFC.)

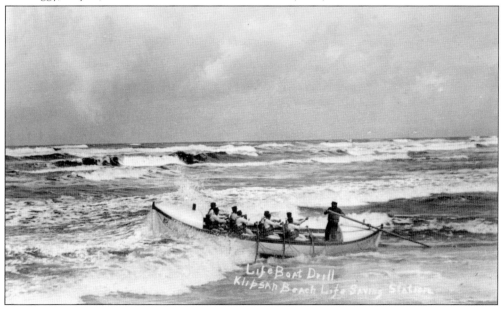

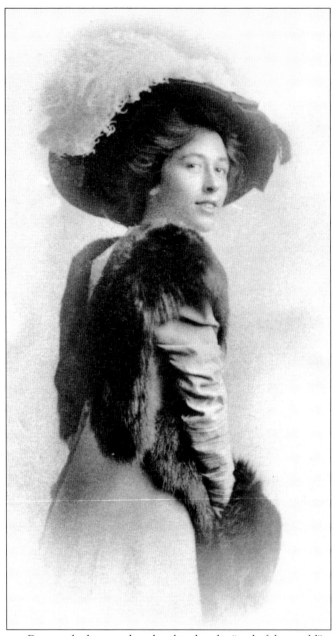

FASHION CONCERNS. Despite the lament that they lived at the "end of the world" or at the "jumping off place," Oysterville residents tried to keep up with the times, and frequent visitors like Cecil Espy's fiancé, Ruth Davis (pictured above), set them a fine example. Cecil's 15-year-old niece, Medora Espy, away visiting in Oregon, wrote to her mother in Oysterville: "Mama, I think we had better plan on a blue suit for winter so that we can have the gray squirrel furs put on it as they would make a cheaper suit look expensive and would also be very becoming to me. Then I could get a new long coat—if they wear them." And her mother replied, "Blue would be nice for your winter suit but not trimmed with my furs—I want them my own self. Fur will probably not be used anyway as it has had two winters run. You will need a long coat. They are always worn in winter. A woman's wardrobe is incomplete without a long wrap." (EFC.)

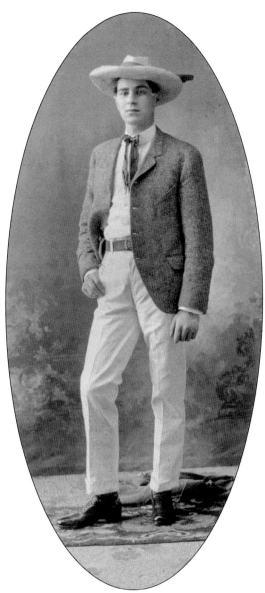

A Young Person's Dilemma. Living in remote Oysterville was perhaps hardest on young people. After graduating from eighth grade, there were two options available: join the work force or, if your family had the means, leave the North Beach Peninsula and enroll in a private secondary institution. For a brief time, from 1895 to 1897, A. B. L. Gellerman operated a school called Peninsula College that occupied the vacated county courthouse. Both grade school and high school (though no college) subjects were offered, including history, German, music, mathematics, athletics, and commercial subjects. The school closed before young Thomas Willard Espy (pictured here) had completed eighth grade. He was sent to Portland Academy for high school and then to Oregon Agricultural College (now Oregon State University.) Like most of his siblings and childhood friends who were able to continue their education beyond the town's familiar two-story schoolhouse, Will returned to Oysterville frequently for visits but never to live full-time. Opportunities were scarce, and families encouraged their offspring to seek their fortunes elsewhere, if they could possibly manage it. (EFC.)

The Home Medical Library

By

KENELM WINSLOW, B.A.S., M.D.

Formerly Assistant Professor Comparative Therapeutics, Harvard University; Late Surgeon to the Newton Hospital; Fellow of the Massachusetts Medical Society, etc.

With the Coöperation of Many Medical Advising Editors and Special Contributors

IN SIX VOLUMES

First Aid :: Family Medicines :: Nose, Throat, Lungs, Eye, and Ear :: Stomach and Bowels :: Tumors and Skin Diseases :: Rheumatism :: Germ Diseases Nervous Diseases :: Insanity :: Sexual Hygiene Woman and Child :: Heart, Blood, and Digestion :: Personal Hygiene :: Indoor Exercise Diet and Conduct for Long Life :: Practical Kitchen Science :: Nervousness and Outdoor Life :: Nurse and Patient :: Camping Comfort :: Sanitation of the Household :: Pure Water Supply :: Pure Food Stable and Kennel

NEW YORK
The Review of Reviews Company
1907

HEALTH CARE. Doctors were few and far between in the early days of Pacific County. On the banks of Shoalwater Bay, as in most of rural America, doctoring was considered a household responsibility, not a professional one. Only in extreme cases was the doctor summoned to Oysterville, probably because the only doctors in the region, Dr. James R. Johnson and Dr. Edward T. Balch, were headquartered on the east side of Shoalwater Bay. Depending upon weather, tides, and where in the county a doctor was at the particular time of need, it could take two or three days or more to get to Oysterville. It was up to the women of the village to deliver babies, care for the sick, and treat the injured. Their knowledge of home remedies and use of local herbs and patent medicines eased the suffering of family members and neighbors, and provided cures for most ordinary complaints. Reference books such as *The Home Medical Library* were a valued addition to a family's household library. When physical strength was required, as in setting bones or lifting and moving heavy patients, husbands and grown sons were called upon for assistance. (Tucker Wachsmuth.)

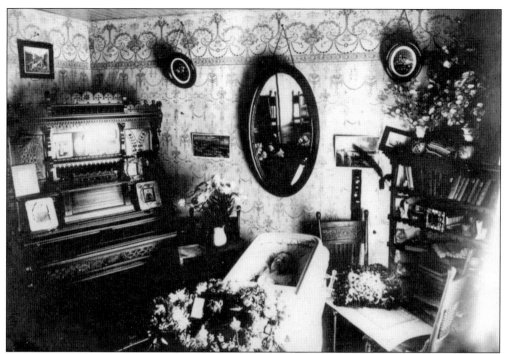

RITUALS. Most people died at home, and death, like doctoring, was generally the province of Oysterville's women. It was the women of the family of the deceased, perhaps assisted by a neighbor, who washed the body and prepared it for burial. Often corpses were dressed in their Sunday best (as was Lizzie Wachsmuth, above) and placed on view in the parlor or bedroom, and friends and family would come to pay their respects. The men were the gravediggers and the pallbearers at the funerals, which, regardless of the religious affiliation of the deceased, usually took place in one of the town's two churches, Methodist or Baptist. Following the service, family members, friends, and neighbors walked behind the coffin as it was taken to the cemetery by horse-drawn wagon, as seen below in Julia Espy's 1902 funeral cortege. Cemetery maintenance is still considered a family and community obligation, with the oldest graves lovingly tended by the fourth, fifth, and even sixth generation pioneer descendants. (Above, Tucker Wachsmuth; below, EFC.)

NEW HOPE. In 1896, Meinert Wachsmuth (pictured above) imported the first Easterns to Willapa Bay, nearly 30 years after their successful introduction in San Francisco. These oysters, *Crassostrea virginica*, were larger than the Natives and were familiar to the vast majority of San Franciscans, most of whom, after all, had come from the East themselves. Freight costs for shipping the oyster seed via the new transcontinental railway were high and, until Wachsmuth's venture, only the two largest companies in the Shoalwater Bay Trade—the Morgan Oyster Company and the M. B. Moraghan Oyster Company—were importing Easterns. Once small Shoalwater growers saw Wachsmuth's success, however, they followed suit, bringing carloads of Eastern seed oysters to Shoalwater Bay. There, they were distributed over the beds ("planted") for two or three years of fattening for the California market. In spite of the continuing decline of the Natives, future oyster prospects in Shoalwater Bay seemed bright. (Tucker Wachsmuth.)

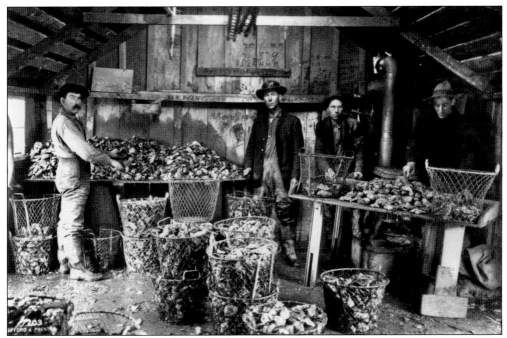

TWO INNOVATIONS. During the time of the Easterns, two important innovations took place on the bay: the construction of oyster stations and the introduction of gasoline-powered launches. An oyster station was essentially a cabin built on pilings in the bay. Located near a company's oyster holdings, a station provided a sheltered place to cull and pack oysters (pictured above), as well as living space for crew members. Most stations were inhabited year-round, especially by Japanese workers. During these years, also, the transition from sail to gasoline power was taking place. The Nelson Brothers and the West Coast Oyster Company, both of Oysterville and both on the cutting edge of the industry, bought the first gasoline-powered launches to be used on the bay—much to the regret of the old sailors of regatta days. (PCHS.)

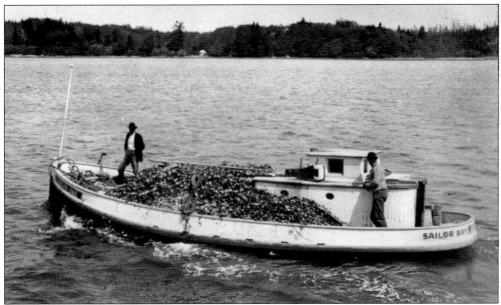

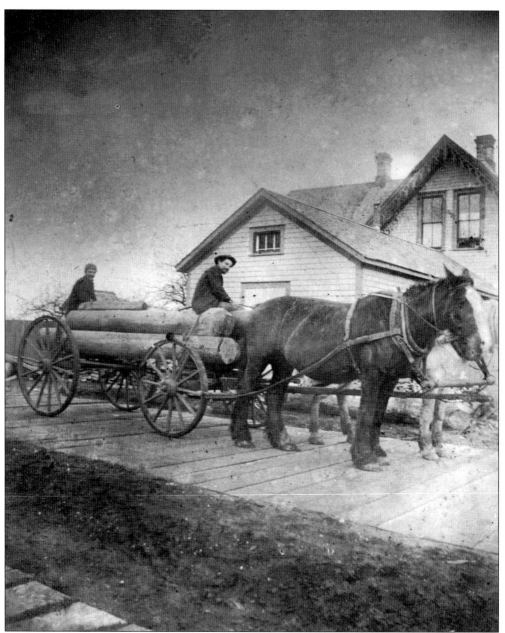

TEAMWORK. Despite the transition on the bay from sail and oar power to gasoline power, activities in town followed the same general pattern they had since the early days. Work was accomplished by "main strength and awkwardness," as the pioneers joked, with men and horses teaming up to get the job done. Whether it was clearing the forest to make room for farmland, planting crops, or building homes, the physical labor of men and horses was basic. There were few specialists; most of the requirements for day-to-day living were built, fabricated, or grown at home. In addition, money was scarce and, inevitably, people were frugal. They saved string and wrapping paper to be reused; they patched and mended clothing and shoes and horse tack; sometimes they made do without entirely. Of necessity, "waste not, want not" was a way of life in Oysterville of the early 20th century. (EFC.)

RECYCLING THE OLD. Deserted or derelict buildings were often moved to a new location or the lumber salvaged and used for a different purpose. A case in point was the courthouse. After it was vacated by the county in 1893, it became the location for Peninsula College for two years and was again pressed into service for classroom space in 1905 when the two-story grade school burned. Finally, when the new schoolhouse opened in 1907, Harry Espy purchased the courthouse building, moving it 1/2-mile south on Sandridge Road. He placed the main building to the west of the road, converting it to a barn (pictured above). Across the street, the courthouse annex was dismantled, and the lumber was used to build Espy's ranch house (shown below), where the foreman of his dairy farm was housed. (EFC.)

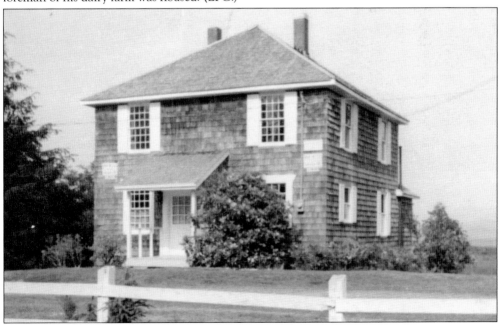

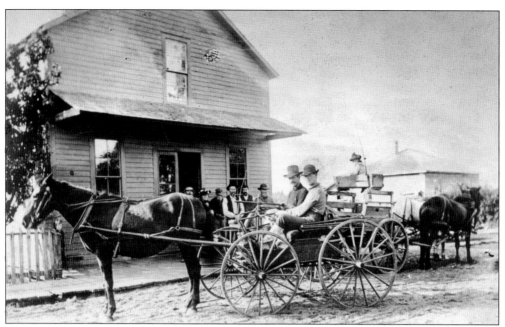

STORE AND POST OFFICE. About 1895, Tom Andrews opened a general store on the west side of Territory Road near Division Street. The store sold a little of everything—coal oil, writing tablets, horse liniment, sewing thread, flour, sugar. Tom, his brother, and a nephew served in turns as postmaster from 1895 until 1918, driving the mail wagon (pictured above) to and from Nahcotta to meet the train. Oysterville's post office was located at the back of the store behind the counter where Tom "held court," passing out mail, selling stamps, weighing out 10-penny nails, and wrapping grocery purchases with brown paper and string. Tom was patient with neighbors who needed credit and generous in dispensing penny candies to children sent to get a much-needed item and asking to "put it on our bill, please." (EFC.)

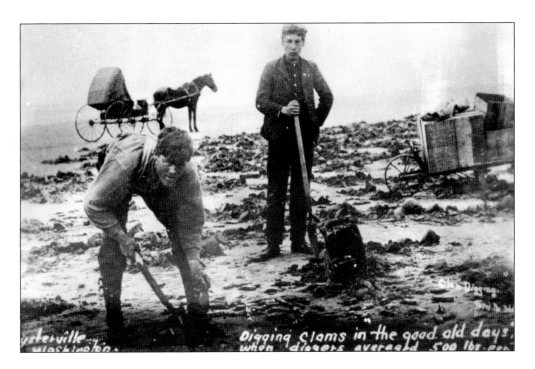

Digging clams in the good old days, when diggers averaged 500 lbs per...

Oysterville, Washington.

Clam Digging

TIDE AND TABLE. The people of Oysterville understood well the age-old adage, "when the tide's out, the table's set," and they depended upon its wisdom when times were hard. At the ocean, scarcely a mile away, razor clams, surf perch, and Dungeness crab were easily obtainable, and on the tideflats in front of town were oysters and buttery mud clams for chowder. Salty pickleweed and goose tongue greens grew in the intertidal marshes and provided zesty accents or alternatives to garden vegetables. Also, commercial clamming and fishing gave opportunities for making some ready money. Seining for salmon on the Columbia River also provided work, particularly for young men who were home from school in the summer. (Above, EFC; below, D&L.)

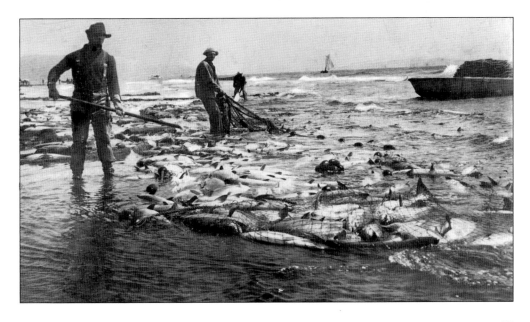

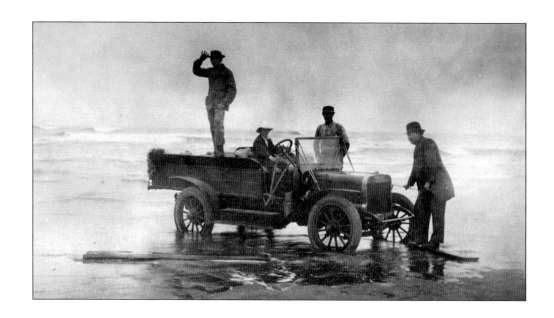

OYSTERVILLE'S FIRST CAR. In the vanguard of innovation in Oysterville was Bert Andrews. He provided the town with many "firsts." Years before Pres. Franklin D. Roosevelt's rural electrification program arrived, electricity was supplied by a Delco system Andrews rigged up in his barn. The power was enough to supply a single light bulb or two in most houses in Oysterville, but it was "lights out" each night at 10 o'clock when Bert and his wife, Minnie, went to bed. Bert's first car, a 1911 Winton (pictured above), arrived in Oysterville by barge from South Bend. To learn how it operated, he took it completely apart and then rebuilt it, piece by piece. He quickly became the recognized authority on automobile mechanisms, and as more cars began to arrive on the peninsula, Bert was the person car owners turned to when they had difficulties. (Charlotte Jacobs.)

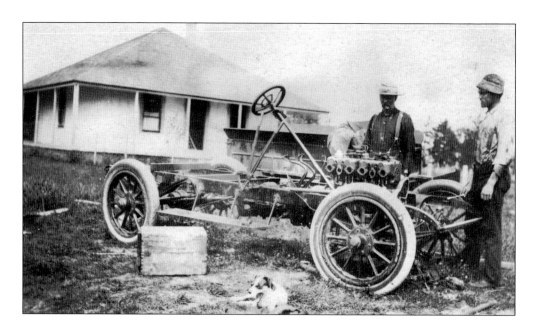

BERT'S FIRST GARAGE. "Bert Andrews was a mechanical genius," according to Dale Espy Little (1911–2009). "He was about 10 years younger than my father, and we all knew that he could fix anything!" Andrews, born in 1886, began fixing things when he was yet a boy, and by the beginning of the 20th century, he had a repair shop with a blacksmithing area toward the back. As the need for automobile repairs increased and owners sought Bert's expertise, the shed-like building began to be referred to as "Bert's garage," and soon another, almost identical, building appeared next to it. The Bert Andrews Garage was expanding! (Above, EFC; below, Charlotte Jacobs.)

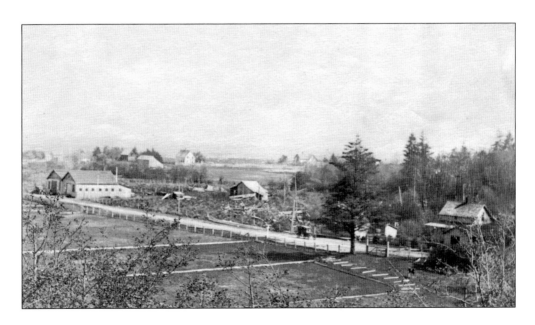

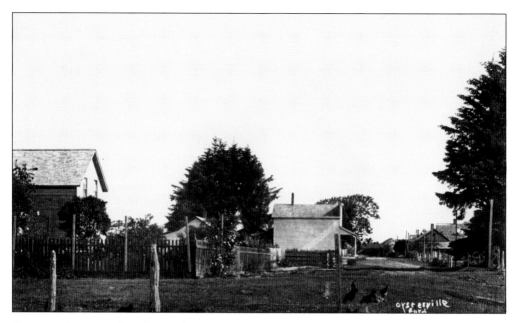

COUNTRY ROADS. Village livestock was still seen more commonly on Oysterville roads than were the new-fangled automobiles. An often-told story was of the teacher who, fresh from the "big city," tripped over a cow in the middle of the road. Making her way home in the dark, apparently without benefit of lantern, she all-too-suddenly came upon "Bossy" dozing on a warm patch of the sandy road. Neither was hurt, but the teacher took a considerable ribbing about her adventure. A few years later, young teacher Helen Thompson (Heckes) guarded against the dangers of working too late at school by using an unusual alarm clock. When she heard Theophilus Goulter's turkeys going to roost in the trees near the schoolhouse each evening, she headed home, thus avoiding the "pitch of the night." (Above, Tucker Wachsmuth; below, EFC.)

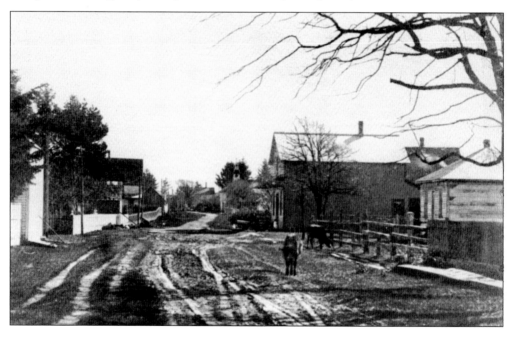

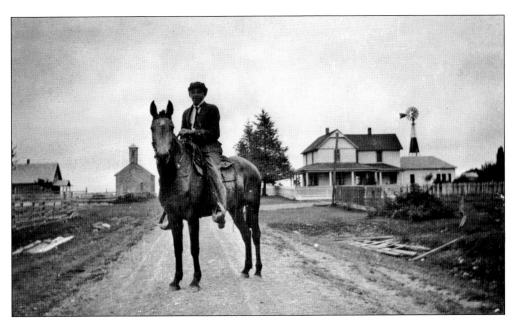

AMENITIES. Although full electrical service, with all its attendant luxuries, did not arrive in Oysterville until 1936, households were not without some comforts of civilization. Rain barrels perched on roof peaks and water-pumping windmills took advantage of the 80-to-100 inches of annual rainfall and constant coastal breezes, providing most women with running water at their kitchen sinks. The wet climate, of course, also caused its share of problems. The sandy soil could absorb only so much water, and then roads and fields became inundated. For some of the in-town thoroughfares, plank roads and walkways were the answer, though keeping them in good repair provided additional challenges. (EFC.)

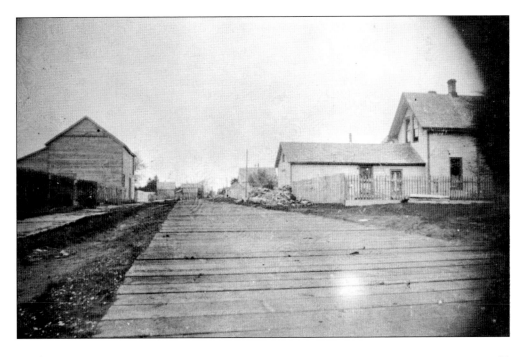

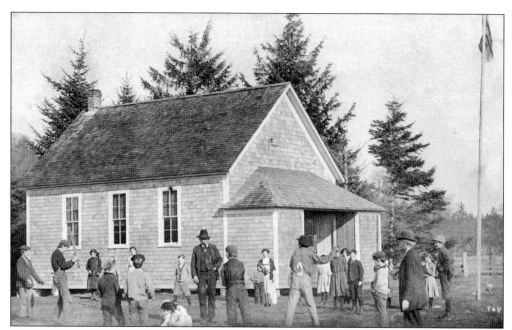

New Schoolhouse. In 1907, the new one-room schoolhouse (pictured above, before belfry) was built. It accommodated all grade school–age children who lived within 3 or 4 miles of Oysterville. Student desks were arranged in vertical rows, the seat of one attached to the desk behind and smaller desks toward the front. The teacher's desk and a recitation table were at the front of the room. A woodstove provided heat, and the older boys kept the wood box filled from the woodpile out back. An American flag was displayed in one corner, and on the walls hung a picture of George Washington, a U.S. map, and several large blackboards. On the porch was a bucket of fresh drinking water with a dipper, and behind the building, near the covered play shed, were the boys' and girls' privies. (Above, EFC; below, Tucker Wachsmuth.)

LARGE FAMILIES. Like rural communities everywhere, large families were the norm. Often, three or four children from one family were attending school at the same time, as was true of the H. A. Espy children pictured above. From left to right are Dale, 2; Willard, 3; Edwin, 5; Mona, 9; Sue, 10; and Medora, 14. By 1914, the little one-room schoolhouse could no longer accommodate all the children in town. The vacant Winslow Store, a few houses south of the Baptist church, seemed a likely choice for a second school building. It had been the company store for the West Coast Oyster Company—a place where that company's oyster workers could purchase general merchandise and put it on the books until harvest time. The company was only too happy to rent the property to the Oysterville School Board for $40 a year. (EFC.)

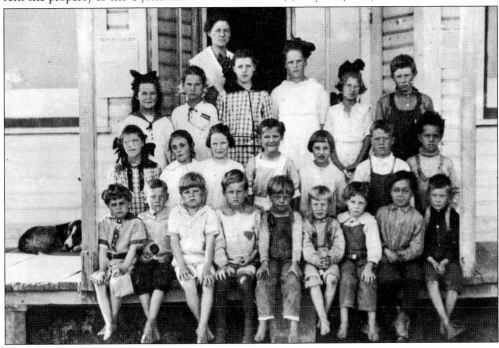

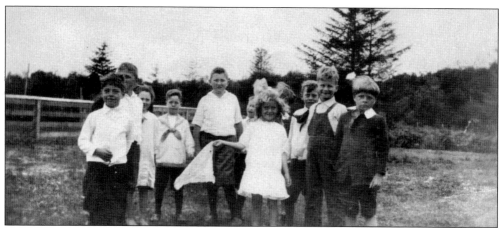

SUMMER FUN. Whether it was playing drop-the-handkerchief at a neighbor's birthday party, or just fooling around down at the bay, an energetic youngster never lacked for something to do. High on the list was exploring, for there was always the hope of finding buried treasure—or at least a gold coin lost on the tideflats in the days of the oyster schooners. Once, when young Willard Espy was poking around in the attic of a deserted building, he came across a skeleton. Terrified, he ran home to tell his father that he had discovered a dead man. It was soon determined that the skeleton was a model left over from a biology class in the days when the courthouse had served as a college, but the hair-raising experience stuck with Willard for another 80-some years. (Tucker Wachsmuth.)

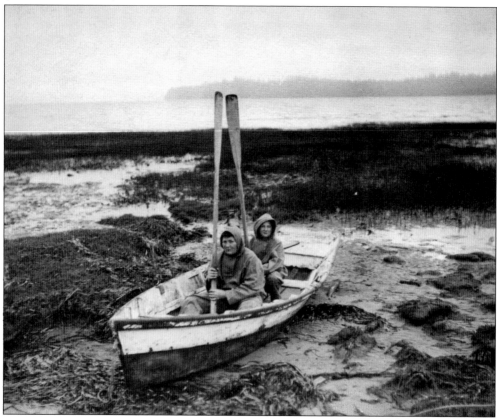

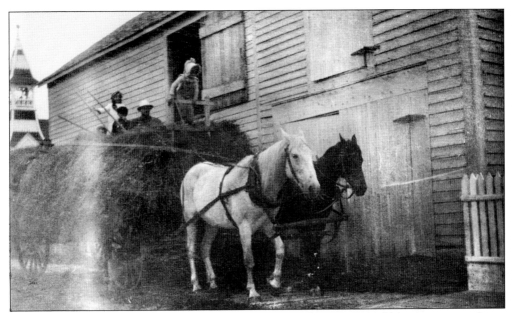

CHORES AND CHATTER. Children considered tromping hay an enjoyable summertime chore, and everyone hoped for an invitation to ride a hay wagon and be among those who would tromp down the hay when it was pitched into the barn loft. Girls especially liked to ride Harry Espy's wagon because he would not tolerate boys teasing with snakes they found in the hay. If nothing else was happening, it was fun to listen in at the Sewing Bee. Village women met several times a month to work on a project for that day's hostess—putting in buttonholes, hemming napkins, or working on a rag rug or quilt. It was also a time to catch up with village news, and children were sometimes shooed away with the remark that "little pitchers have big ears." (EFC.)

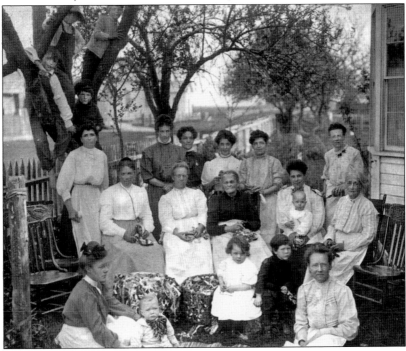

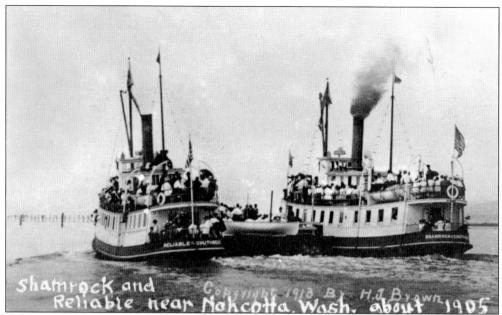

Shamrock and
Reliable near Nahcotta. Wash. about 1905
Copyright 1913 By H.J.Brown

IMPROVED ACCESSIBILITY. Although the North Beach Peninsula continued to be accessible only by water well into the 20th century, transportation methods were beginning to improve. By 1906, the twin steamers *Shamrock* and *Reliable* were transporting people, mail, and freight to points all around the bay on a fixed schedule. They met the train twice daily at Nahcotta and, in addition, connected with the Northern Pacific in South Bend, effectively linking the Shoalwater region with inland areas to the north and east. By 1920, the first car ferry, the *Tourist*, began operating between Astoria, Oregon, and Megler, Washington, similarly connecting passengers and their automobiles with areas to the south. Progress had arrived, and soon, talk of improved land transport began. (Above, EFC; below Rodney Williams.)

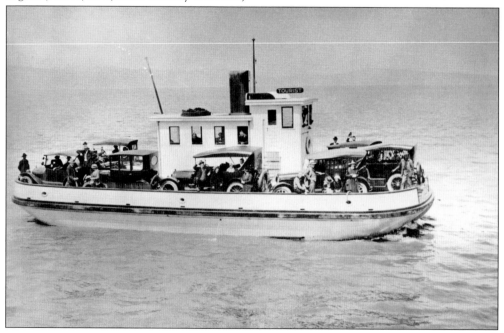

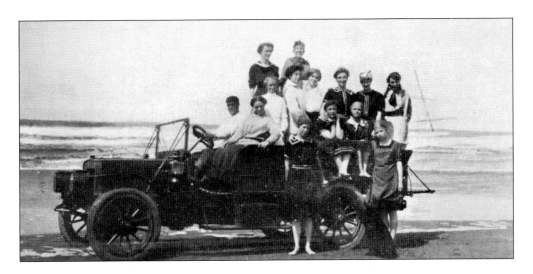

THE ROAD STILL TRAVELED. For some years after automobiles began arriving on the North Beach Peninsula, the train continued to be the principal means of land transport. Even though the old wagon roads were gradually improved as auto use increased, until the 1920s the only north-south route from Ilwaco all the way to Oysterville was along the Weatherbeach, the old route that early stagecoaches had traveled. Driving on the hard sand of the Beach Highway was not only a useful way to get from town to town, but it was a popular pastime for residents and visitors alike. The 28-mile stretch remains an official state highway and retains its appeal to joy-riders. (Above, EFC; below, Charlotte Jacobs.)

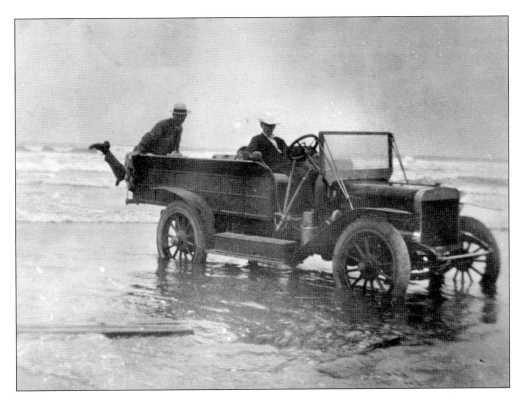

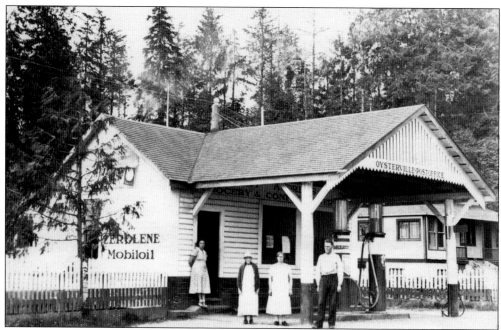

A NEW POSTMISTRESS. In 1918, Sam E. Andrews convinced his sister-in-law, Minnie Andrews, to take over his postal job. The post office was relocated from Tom's old store to a small building behind Bert Andrews's gas pumps. Next door, just east of Davis Hill, was Minnie and Bert Andrews's house. Minnie served as postmistress for 27 years, making a total of 49 years, 11 months served by members of the Andrews family, Sam I., Tom, Sam E., and Minnie. Mail duties were a team effort, with Bert delivering and picking up mail sacks at Nahcotta each day at train time. As long as he was at it, he picked up supplies for his neighbors, gradually enlarging the little post office building to accommodate hardware and groceries. By then, his was the only general mercantile business in town. (Charlotte Jacobs.)

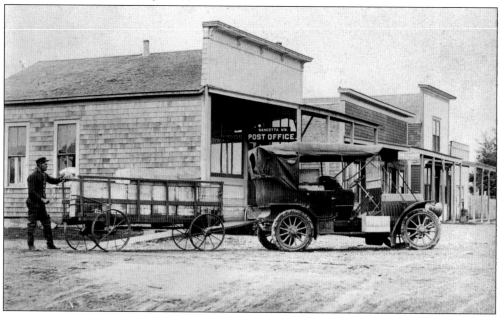

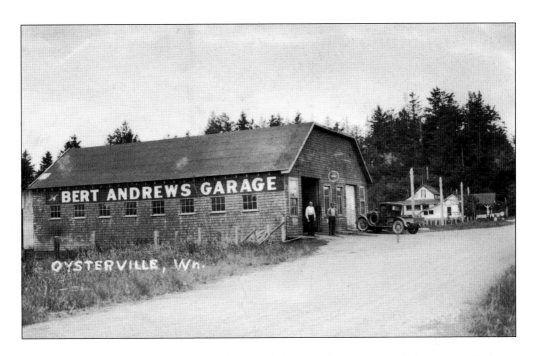

PROSPERING BUSINESSES. In addition to his mail delivery and store responsibilities, Bert Andrews continued to provide most of the mechanical expertise for Oysterville and other north end communities. Even after he had turned the garage business over to son Carl, he was sought after. Most famously, in later years, U.S. Supreme Court justice William O. Douglas had Bert do the fine-tuning on his airplane each time he came to the beach. Across from Bert's garage was the home of the equally well-known and well-respected Oysterville resident Alexander Holman, a blacksmith during Oysterville's heyday. His tidy cranberry bog produced a record 208 barrels per acre in 1918 and was much admired by other growers in the area. Oysterville residents took pride in the attention it brought to the village. (Charlotte Jacobs.)

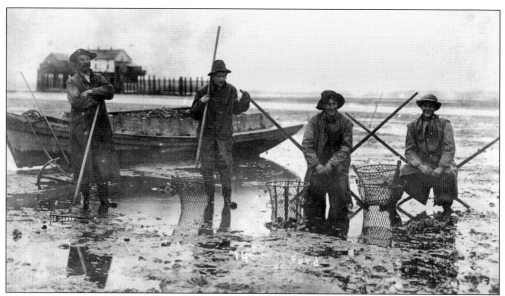

OYSTER FAILURE. In 1919, the Easterns failed. Their foothold in Willapa Bay had been tenuous at best, for though they prospered in West Coast waters, they did not propagate out of their native Chesapeake Bay environment. Oyster seed (also called "spat-on-shell," or "cultch") was transported west by the train carload, an expensive but financially viable endeavor until East Coast oyster farms began to decline and prices became exorbitant. Seed importation stopped in 1913 but, because of extensive beds of Easterns still in the bay, they continued to be marketed, reaching 19,000 gallons in 1918. The next year, however, a massive, unexplained environmental incident destroyed most oyster beds in the bay, and the time of the Easterns was over. The oyster business as it had been known in Willapa Bay was no more. (Above, Charlotte Jacobs; below, Dobby Wiegardt.)

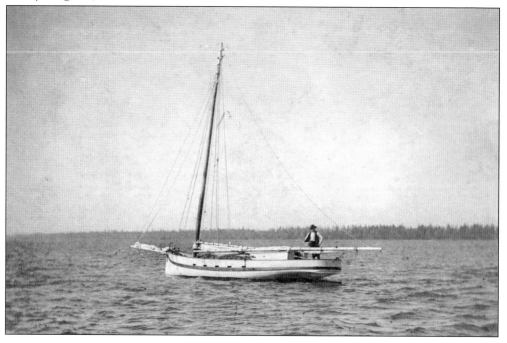

QUIET ON THE BAY. With the failure of both the Native and Eastern oysters, most activity on Willapa Bay came to a standstill. Abandoned boats dotted the shoreline, much like deserted houses had lined the streets a generation or two before. For the first time since white settlement, the primary attraction of the bay became recreational. Families and friends went for outings when tides and the weather cooperated or had impromptu crab bakes on the sandy beach. Children like Albert and Medora Espy, pictured below, delighted in wading in the warm, shallow water and spent hours looking for baby sea creatures under the old ballast rocks, dumped near shore during long-ago schooner days. No longer was the bay considered a major source of livelihood; only the most optimistic hoped for an oyster revival. (Above, Tucker Wachsmuth; below, EFC.)

THE BOARDINGHOUSE. In 1919, the same year that the Easterns breathed their last, the four Caulfield sisters came to Oysterville and bought the John Crellin house from Tom Andrews. "Aunt Rye, Aunt Ev, Aunt Nanny, and Aunt Ann," as they were affectionately known by family and friends, had come west in 1903 from Minnesota, where they had farmed and had taken in boarders. Following their custom, they ran a boardinghouse in Portland for many years and then decided to open a summer place at the beach. They divided the labor: Aunt Nanny was the business manager and cooked the meat and seafood; Aunt Ann was the bread, biscuit, and pancake maker; Aunt Rye made pies and desserts; Aunt Ev was in charge of vegetables. Summer visitors flocked to Oysterville. (Above, HKF; below, EFC.)

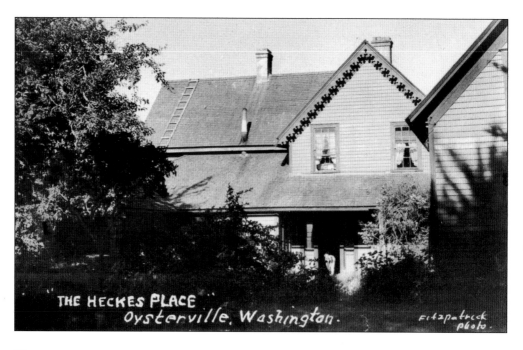

"THE HECKES PLACE" Oysterville, Washington.

Fitzpatrick photo.

Dining room
Heckes Place
Oysterville, Wash.

SUMMERTIME BUSTLE. "The Heckes Place," as the boardinghouse was called by some, did a thriving business each summer for 20 years, eventually overflowing into several other residences in town. Food critic Duncan Hines visited and highly recommended it in his travelers' guides. The fare was not only home cooked, but was also mostly homegrown. Uncle John Heckes, Aunt Nanny's husband, tended the orchard and large vegetable garden, where "weeds didn't dare to grow," according to all who spoke of his diligent husbandry. He also raised cows, pigs, and chickens, and their son Glen, an oysterman, supplied seafood of every description. During the busy summer months, young people throughout the village were hired to wait tables, make beds, wash windows, or pack lunches for guests. Just before World War II, the aging sisters closed the boardinghouse, but family members continued to live there for another generation. (HKF.)

A Cheery Corner at
The Heckes Place, Oysterville,
Washington

photo by
Fitzpatrick

A VISITOR'S VIEWPOINT. In 1926, thirteen-year-old Ruth Elinor Frerichs wrote to her cousin Alice from her family's vacation rental home in Ocean Park: "We followed the so called 'highway' about 5 miles to a town called Oysterville on the bay. A long time ago it was quite a good-sized town, having a large oyster industry, a fair-sized college, and the court house. Ships came up from San Francisco, Cal. With large loads of redwood and exchanged them for oysters. The oyster industry finally fizzled out, the court-house was changed into a barn, the college was torn down, till, little by little, the town dwindled into a scraggly village of about 50 people and a lot of blackberry vines. Failure seems to be written in big letters everywhere one looks." (Charlotte Jacobs.)

Five

RESURGENCE

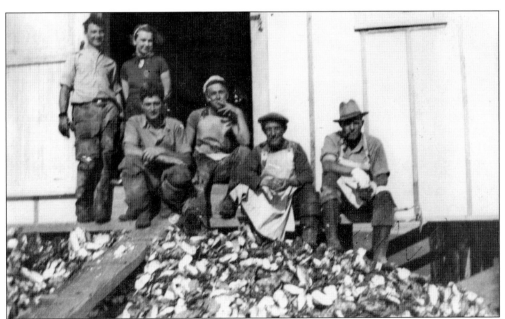

THE 1930s. Although Oysterville had diminished in size sufficiently to qualify as one of the state's ghost towns, the successful introduction of a third oyster culture to Willapa Bay in the 1930s soon brought a renewed climate of optimism. Oystermen and cannery workers, such as those posing in front of the Sherwood Company, once again provided a feeling of stability and blue-collar productivity to the little village. (TSF.)

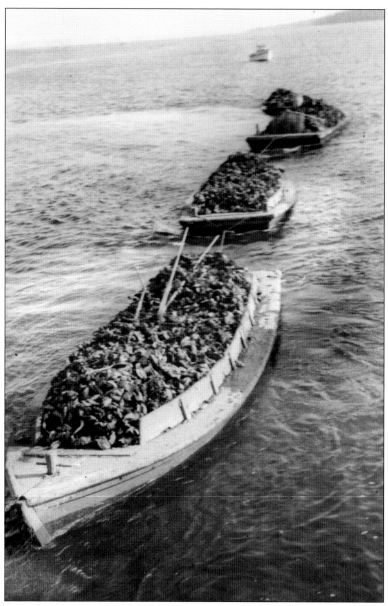

GIANT JAPANESE OYSTER. As early as 1902, experimental planting of seed oysters from Japan had begun along Washington's coast. By 1906, the Japanese oyster (*Crassostrea gigas*) had been introduced to Willapa Bay. The species thrived, but since the Eastern oyster business still flourished, the possibility of propagating a new oyster variety in Willapa Bay aroused little interest. By comparison with the tiny Natives and the relatively small Easterns, the Japanese oysters seemed gross and unattractive. Oystermen felt they would not be readily acceptable to the buying public. The failure of the Easterns in 1919, however, prompted a change in thinking and, in 1928, a trial planting of Japanese oysters was made in Willapa Harbor under the direction of University of Washington biology professor Trevor Kinkaid. So successful was the planting that yet another oyster boom began on the bay. New companies were formed, a brisk promotion in the acquisition of tax-delinquent oyster lands developed, and the decision was made to call the oysters "Pacifics." (TSF.)

OYSTER SHIPMENTS. Oyster seed came across the Pacific Ocean riding piggyback aboard the shells of previously harvested oysters. When the seed boats arrived, in February or March, oystermen picked up their orders, which came in wooden packing cases, each containing about two bushels of spat. By the spring of 1933, 15,207 cases were shipped to 45 individuals and corporations on Willapa Bay, including many of Oysterville's growers. As they had done in previous years with the Easterns, oystermen planted Pacifics from their bateaux by the shovelful, scattering the cultch on the water so it would settle evenly onto the beds. In those early years of the Pacifics, the oysters matured to marketable size in 18 months, and one case of seed could produce 100 gallons of meat. (Above, HKF; below, EFC.)

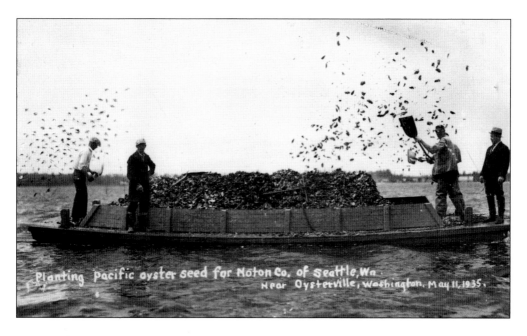

Planting pacific oyster seed for Moton Co. of Seattle, Wn.
Near Oysterville, Washington. May 11, 1935.

END OF AN ERA. As motor traffic increased, existing roads improved dramatically, and new routes promised an end to the peninsula's isolation. By the mid-1920s, a route around the bay from South Bend and another along the river from Longview made it possible, for the first time, to reach the North Beach Peninsula by auto without a water connection. Gradually, as year-round and summer residents discovered the increased independence provided by automobiles, travel by train decreased. Nor could the railroad compete with the lower rates and door-to-door delivery service of emergent trucking companies. On September 9, 1930, Locomotive No. 2 made its last run on the little narrow-gauge rail line and, once more, life in Oysterville and all over the peninsula was forever changed. (Above, Charlotte Jacobs; below, EFC.)

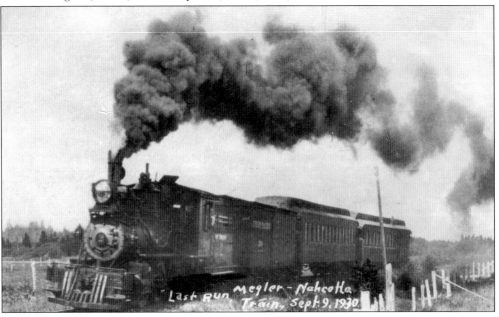

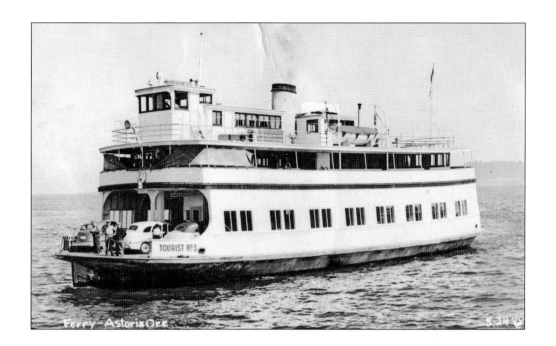

TRAFFIC INCREASES. With the termination of train service and the improvement of roads, automobile traffic on the North Beach Peninsula rapidly increased. In 1931, Capt. Fritz Elfving added another, larger car ferry, the *Tourist III*, to his Astoria-Megler run. During the summer months, when visits to and from North Beach reached their peak, both the *Tourist II* and *Tourist III* were placed in service. Oysterville, too, had its share of traffic in the summer when the Heckes Place was operating at full capacity, and it was not unusual to see cars parked bumper-to-bumper along Territory Road. (Above, Charlotte Jacobs; below, HKF.)

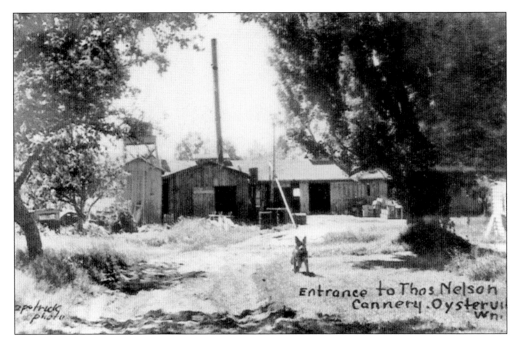

Entrance to Thos. Nelson Cannery. Oystervi, Wn.

THE CANNERIES. Since the large size of Pacifics made them unpalatable for oyster cocktails or oysters-on-the-half-shell, oyster growers quickly promoted recipes for cooked oysters, and canneries sprang up all around the bay. In Oysterville, Eddie and Millie Sherwood opened the Sherwood Company in their backyard. Their logo was a little Robin Hood figure. Sherwood's smoked oyster spread became a popular commodity with the army in World War II. Tommy Nelson opened his cannery (pictured above) in a collection of weathered buildings behind his house, just south of the Baptist church. His "lightly smoked" oysters were in demand as far off as New York City. But far and away the largest enterprise in Oysterville was the Northern Oyster Company (shown below), begun by Ted Holway, Glen Heckes, and Roy Kemmer. (Above, Peter Janke; below, EFC.)

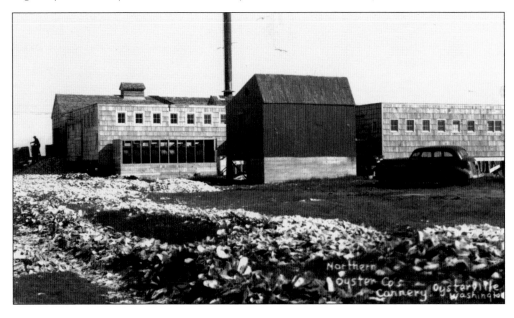

Northern Oyster Co.s Cannery. Oysterville, Washington

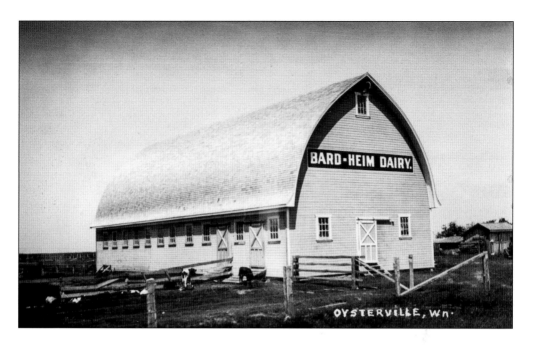

BARD HEIM BARN. In 1935, Dr. Bard, a minister from the Midwest, built the Bard Heim barn and house at the north end of town. Because local carpenters refused to tackle the immense barn roof, shipwrights from Aberdeen, Washington, were brought in to build it. When Oysterville farmer Martin Olson learned that the property was for rent, he went to Harry Espy, justice of the peace, for assistance. According to Martin's son, Tommy (1924–2007), "My father came from Norway . . . and had a very strong accent. Mr. Espy was the leader of the village of Oysterville and he smoothed the way for Dad. At that time Dad had 85 cattle and 3 horses. At that meeting my father rented the Bard Heim Dairy and the bay acreage north of Oysterville." (Above, EFC; below, HKF.)

WACHSMUTH COTTAGES. In 1939, Harry and Louise Wachsmuth replaced the old, original Wachsmuth house with a smaller house and four cabins, which were situated in a row along School Street. Although their intention may have been to rent them as tourist cabins, in reality, it was their family members who utilized them most. Their grandson Larry Freshley remembers, "My parents moved to Oysterville into one of my grandparents' cabins, which was a stone's throw from the school. My dad was about to report for his physical to enter the army and Oysterville at my grandparents' was a good place for the family during his absence. As it turned out, dad did not meet all of the physical requirements for military service. Since we were settled into the cabin, Oysterville was now our home. I entered the first grade in Oysterville at 5½ years of age, well into the start of the 1943–1944 school year. Dad went to work in the oysters, and my parents raised four kids in Oysterville." (Tucker Wachsmuth.)

BEACH DRIVING AND BEACHCOMBING. A favorite pastime of residents, as well as visitors, was to take a drive along the ocean beach to see what changes the last high tide had brought. Wonders were many, from sand dollars and starfish, to oddly shaped driftwood. Occasionally, a bonus would occur—perhaps hundreds of pairs of shoes or a load of dimension lumber that had washed off the deck of some hapless freighter and had found its way to the Oysterville beach. The best time to search for the coveted Japanese glass fishing floats was when the tide had receded after a storm. Serious scavengers sometimes went before daylight, rigging lights on their vehicles that would reflect back from the glass balls hidden amongst the flotsam along the tide line. (Above, EFC; below, Charlotte Jacobs.)

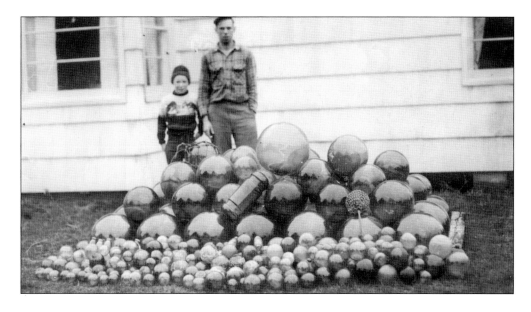

THE DISAPPEARING SHORELINE. In the 1890s, Major Espy had become concerned that the encroaching tidewaters of the bay were going to wash away "his" town. In an attempt to stave off impending disaster, he had a 1-mile-long fence of pilings built along the shoreline from Oysterville Road southward. A century later, the vestigial pilings were still visible (pictured above), but the relentless tide continued to overflow its banks, especially during winter storms. Every few years a hurricane-force storm coincided with the highest tides of winter. Then the bay, driven by strong winds, would flood the meadows, lanes, and gardens of the village, and for two or three hours Oysterville would become an eerie seascape dotted with trees and houses and picket fences. (Above, TSF; below, EFC.)

VILLAGE STREETS. Major Espy's fence notwithstanding, the bayshore continued to erode. Some streets did, indeed, disappear. Front Street, the location of early boat builders and sail makers, was constructed on a pier paralleling the water's edge. It had fallen in once the businesses were abandoned. As the population diminished, the two streets just west of Front Street fell into disuse, and they, too, all but vanished. By the early 20th century, Territory Road was the one remaining north-south street through town. The homes along its easterly side faced the bay, but as access from that direction disappeared, front doors became back doors, and the backs of houses became the fronts. Sharp eyes could still pick out the locations of First and Main Streets eastward of the old fence lines. Of the eight streets running east-to-west, only Pacific Street went all the way from bay to ocean, changing its name to Weatherbeach Road as it neared the westerly outskirts of Oysterville. Clay, Merchant, and Division Streets, the grassy avenues leading to the bay from Territory Road, were generally called "the lanes." (Sydney Stevens.)

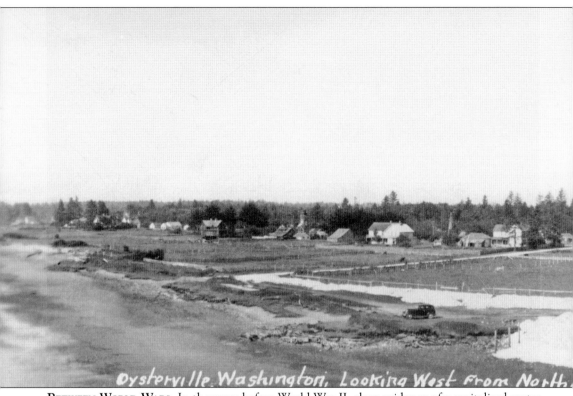

Oysterville, Washington, Looking West From North.

BETWEEN WORLD WARS. In the years before World War II, clear evidence of a revitalized oyster industry—increased activity on the bay and busy canneries in town—brought a returning sense of equilibrium to the little community. Of necessity, Oysterville had become more a farming than an oystering community, and there was an almost audible sigh of relief as the focus returned to the bay. For the first time in several decades, many households geared themselves to tide tables

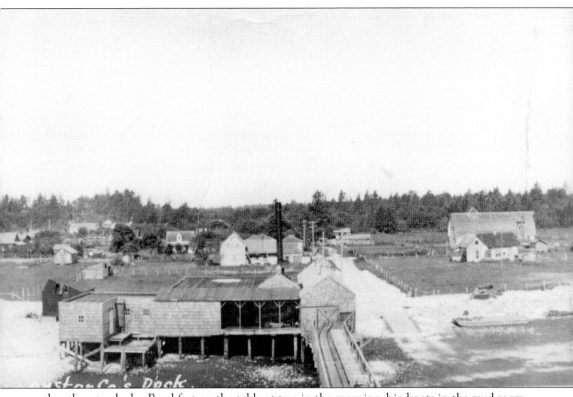

rather than to clocks. Breakfast on the table at two in the morning, hip boots in the mud room, and long johns and boot socks drying by the wood stove became commonplace once again in the homes of oystermen. Oysterville felt itself moving forward after the years of the Great Depression, which had come hard on the heels of the waning Eastern oyster business. (Charlotte Jacobs.)

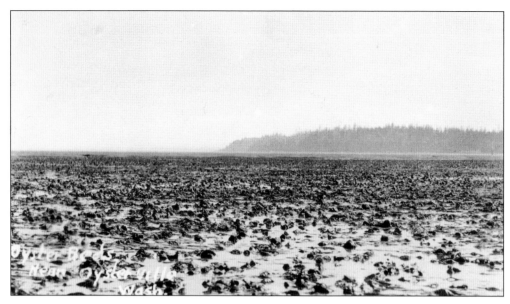

VIGOROUS NEW SPECIES. The Pacifics not only grew well in local waters, but happily, in contrast to the Easterns, they soon began to reproduce in some areas of the bay. By the end of the 1930s, thousands of acres of wild or unused tidelands on Willapa Bay, including the denuded State Reserves, were dotted with small beds of unplanted Pacific oysters. Even so, some oystermen continued to purchase seed from Japan until 1941, when World War II shut off the annual seed imports and the Pacific oyster industry became solely dependent on locally caught seed. On the landward side of the oyster industry, public relations efforts achieved increasing success. Labels on cans of steamed oysters cited the health benefits to be gained by eating "pure" oysters from Willapa Bay. Sales soared. (EFC.)

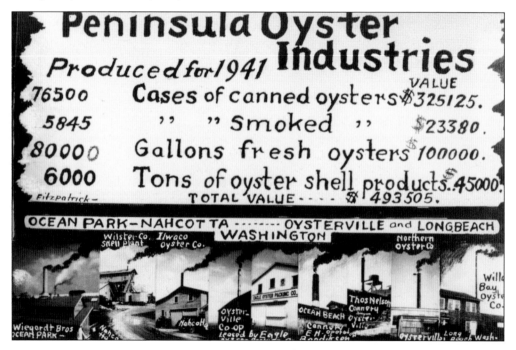

OYSTER SETS. Oysters begin life as free-swimming larvae, but after two or three weeks they must permanently attach themselves to a hard surface in order to continue growing. They prefer to attach to other oysters. On the cultivated tidelands of Willapa Bay, growers reused oyster shells to provide a surface for the newborns. The swarms of larvae attach to the shell, referred to as a "set," only when water temperatures and other climatic conditions are optimum. Some years were better than others. A legendary set occurred in 1936. Baby oysters covered every hard surface in the bay, including pilings, floats, and boat bottoms, even a discarded shoe. Extreme sets, however, also had their downside, with too many oysters vying for available nutrients. Like all farmers, oystermen were also often the unwitting victims of Mother Nature. (Above, HKF; below, CPHM.)

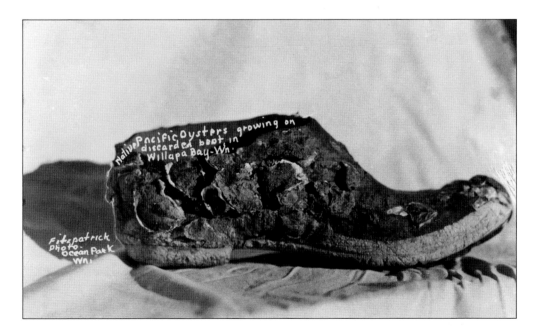

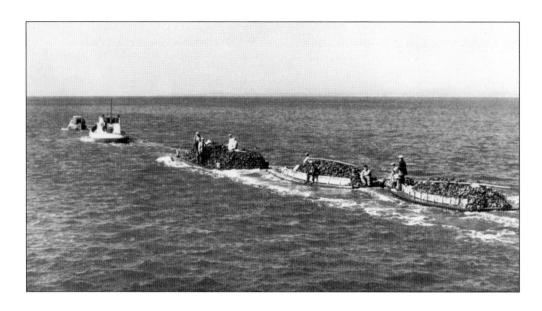

FARMING CHORES. Strings of ubiquitous bateaux (pictured above), the sturdy workhorses of the industry since sailing times, could be seen year-round on the bay as they transported oysters from one area to another, depending upon their stage of development. Newly settled oysters, called "spat," were overwintered in intertidal waters, ideal for developing thick shells and strong muscles. When ready for planting, they were taken to grow-out beds for a year or two, where they grew into large clusters or clumps. At that point they were broken apart and scattered by workers called "cluster busters," who were told to "throw them where they ain't" (shown below). Finally, the oysters were transported to fattening beds near the mouth of the bay, giving them access to the maximum amount of nutrients. (Above, CPHM; below, Dobby Wiegardt.)

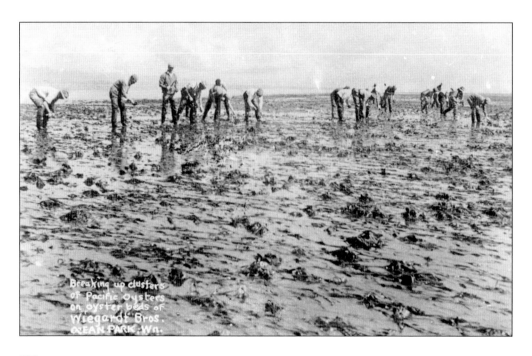

DURING WORLD WAR II. From 1941 to 1945, the importation of oysters from Japan ceased. Early in May 1942, citizens of Japanese heritage were whisked off to relocation centers with only a few days' advance notice, adversely affecting the oystering workforce as well as most communities on the peninsula. The ocean beach was off-limits to all but the U.S. Coast Guardsmen who kept a constant patrol on horseback. Blackout curtains were in place on every window, and only emergency driving was allowed at night using special shields over head and taillights. Oysterville residents collected sphagnum moss for bandages, knitted socks and sweaters for soldiers, and donated scrap metal such as the old jail bars (shown below), displayed by Harry and Louise Wachsmuth. School children bought War Bonds, and parents dealt with rationed gasoline, shoes, and food staples. (Above, John McNamara; below, Tucker Wachsmuth.)

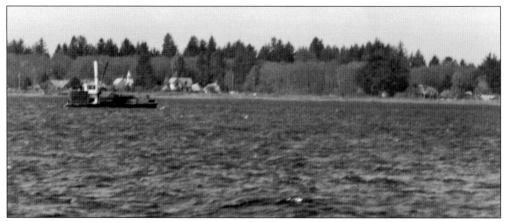

MODERN INNOVATIONS. Despite the cessation of seed imports from Japan, on Oysterville's bay front it was business as usual thanks to good oyster sets during the war years. In the canneries, however, canning was brought to a standstill due to tin conservation and other war-related measures. Many canneries were converted to opening houses, where, for the first time, women made up a large part of the work force, and thousands of gallons of fresh oysters were frozen for overseas use by the army and navy. Meanwhile, improved systems for harvesting, transporting, and processing oysters were being developed. Power dredges (pictured above), which could mechanically harvest oysters off the bay floor, now replaced most hand-tonging and picking, and power conveyors saved many man-hours in the canneries and opening houses. Gradually, the industry was being modernized. (Above, HKF; below, CPHM.)

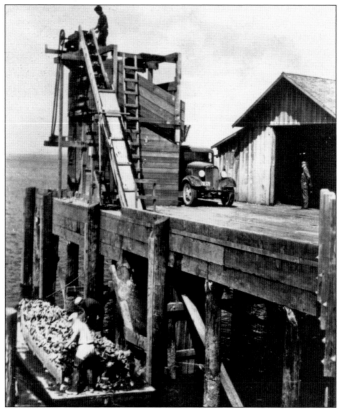

SUMMER WORKFORCE. "All the kids worked. It was the normal thing to do, just like going to school," said Larry Freshley, pictured in 1952 at age 14. His boots were "red rubber with white trim around the feet. I loved my boots!" The gloves were supplied by his boss, Ted Holway, and the parka was a surplus item that his dad got in Portland. "We worked the low tides and 'scattered' oysters, breaking apart clusters. A typical workday may have been four hours. We were paid an hourly wage of $1.67, so each day that we worked amounted to around seven dollars and change. A tide run would start very early in the morning and would last seven to ten days. Then there would be a few days off before the next tide run. As I got older, I worked on different jobs in the oysters. The summer of '55 I worked long hours but made good money, averaging $23 to $24 a day. I made enough to pay for a full year of college." (Larry Freshley.)

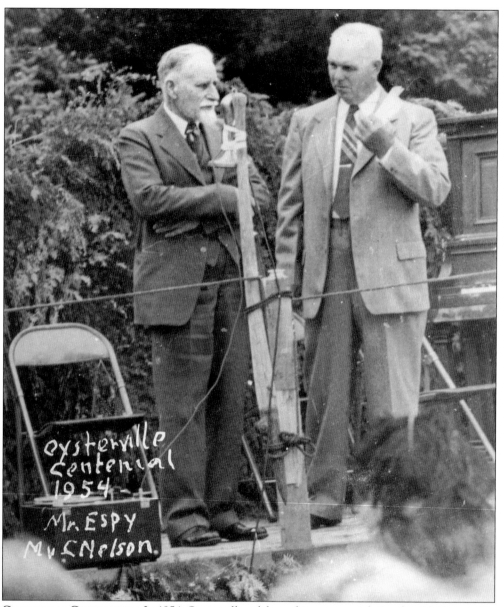

CENTENNIAL CELEBRATION. In 1954, Oysterville celebrated its centennial. People with Oysterville connections gathered from far and near. The auspicious occasion began with a delegation of Chinook Indians, who arrived by canoe to commemorate their part in the town's founding 100 years previously. Everyone had stories to tell and memories to share about experiences growing up, working, living, or visiting in Oysterville. Speeches were made, and descendents of the pioneers, like second-generation native sons Harry Espy (left) and Charlie Nelson (right), recounted the history of the village, the oldest surviving town on the bay. The celebration took place at the schoolhouse, where picnic tables had been set out, and a makeshift stage, complete with public address system, had been set up on the back of a truck. "There wasn't anything fancy," remembered Dora Espy Wilson (1872–1955). "We brought our own lunches and did a lot of talking and laughing. We were just celebrating the town and its survival. And probably our own survival, as well!" (EFC.)

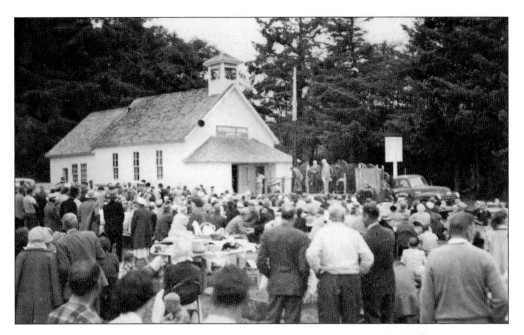

A Day to Remember. Many remarked that the centennial crowd was the largest gathering in Oysterville since "Court Days," when the town was still the Pacific County seat. To commemorate the occasion, Vance Tartar created a seal depicting a high prow dugout canoe, an oyster schooner, a cannery building, and a pile of oyster shells—a succinct visual account of the town's history. It was stamped on envelopes sent by the Oysterville post office in honor of the grand occasion and would be kept and admired by recipients for many decades to come. A half century later, when the village celebrated its sesquicentennial and, in 2008, when the post office celebrated its sesquicentennial, Tartar's design would be used again. (EFC.)

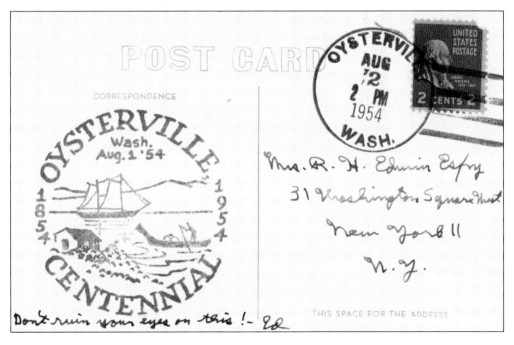

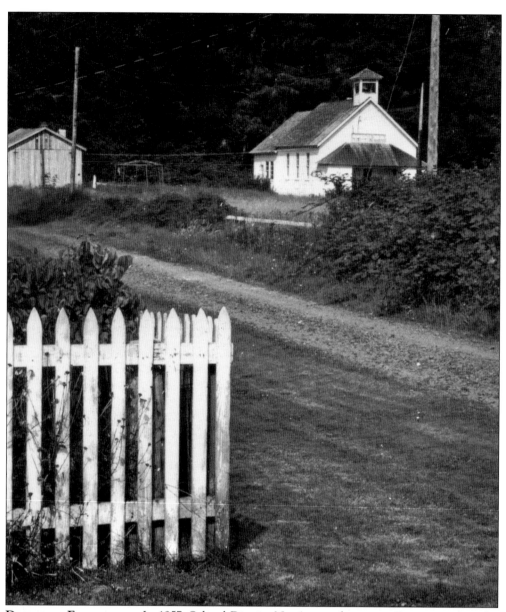

DECLINING ENROLLMENT. In 1957, School District No. 1 ceased to exist. For some years, the little one-room schoolhouse had served only grades kindergarten through six, rather than the traditional eight grades of its early decades. Seventh and eighth graders from Oysterville rode the school bus to Ocean Park School, and older students continued on to the consolidated high school in Ilwaco. By the 1956–1957 school year, however, there were only seven students in attendance at the Oysterville School. Although the school board had been resisting pressure to close the school for many years, they finally conceded to the reality of declining enrollment, and Oysterville consolidated with the Nahcotta–Ocean Park School District. The little school building, now empty, was leased to the Oysterville Improvement Club, an outgrowth of the earlier Sewing Bee. Reorganized as the Oysterville Community Club, the group expanded to include all members of the village and vicinity, and continues to function as the town's social center. (William Y. LaRue.)

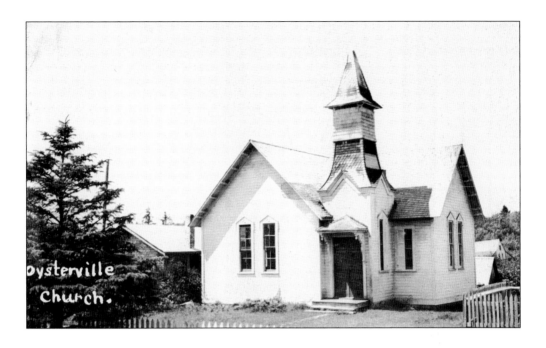

RAVAGES OF TIME. Once again, the village began to look and feel neglected. The steeple of the Baptist church had long since been boarded up against the weather. As long as he was able, across-the-street neighbor Harry Espy watched out for the building, keeping it swept and patching the roof as needed. Once a visitor saw him puttering around the churchyard and asked, "Sir, do you belong to this church?" "No, sonny," was Espy's reply. "This church belongs to me." In a way, he was correct. When his father, Major Espy, had donated the land and building to the Baptists, he had specified that they should revert to the Espy family if ever the Baptists no longer used them for church purposes. Other buildings in town suffered as well, and Oysterville slumped into another decline. (Above, Charlotte Jacobs; below, EFC.)

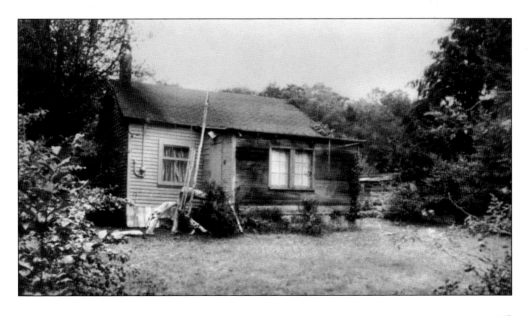

A Closed Chapter. In the 1960s, the Northern Oyster Company closed down its operation at the Oysterville cannery, and for the first time in more than a century, there was no oyster presence in the village. Those who were still in the oyster business had transferred their base of operations to Nahcotta, where port facilities provided deep-water moorage for their boats and the oyster industry was in full swing. The closing of the cannery seemed to portend the end of Oysterville itself. With no employment possibilities, no village school, an aging population, and only a ragtag collection of weather-worn buildings, it was difficult to imagine that the town could last another decade. Against all odds, the store and post office hung on, assisted by the patronage of increasing numbers of residents at Surfside, the growing development of houses on the ocean dunes. But, overall, the future did not look bright for the little community on the bay. (EFC.)

Six

RENOWN

MORE CHANGES. By the 1970s, more changes were happening on the bay and in Oysterville. On the tideflats in front of town, residents were harvesting steamer clams—small Manila clams that had come in with the Japanese oyster seed and had gradually established themselves in Willapa Bay. In short order, oystermen began to buy up the second-class tidelands where the clams proliferated, and a new shellfish industry mushroomed. (Sydney Stevens.)

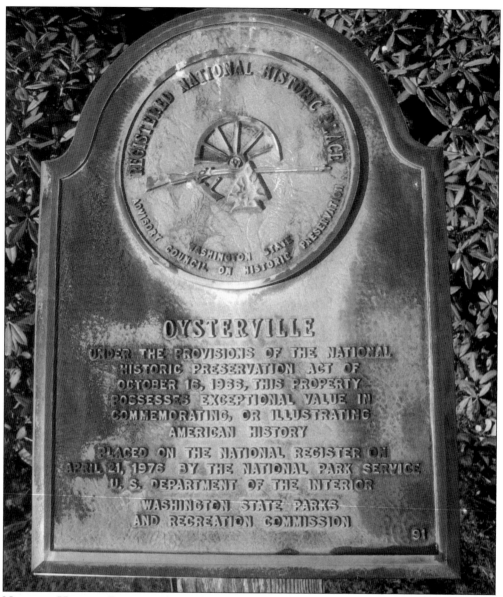

NATIONAL HISTORIC DISTRICT. In 1970, Bill and Dale Espy Little retired and moved into the house across from the church—the house where Dale had grown up in the early decades of the 20th century. "It was as if the town had been holding its breath, waiting for Dale to come back," her friend Edith Slingerland Olson (1904–1995) often said in the years that followed. "She saw the town disintegrating and found a way to save what was left." Dale spearheaded a drive to put the village on the Register of National Historic Places. She familiarized herself with the requirements involved in such an undertaking, enlisted the help of neighbors, friends, and family, and spent hours at the county assessor's office researching the history of Oysterville's buildings. She then set out to have Oysterville host a peninsula-wide celebration for the nation's bicentennial. On July 4, 1976, in front of 1,000 people gathered at the schoolhouse, Oysterville was presented with its National Historic status by Carolyn Feasey of the Washington Trust for Historic Preservation. (Nyel Stevens.)

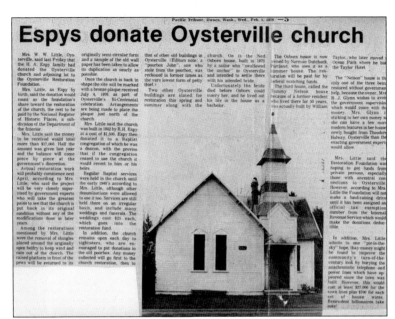

Pacific Tribune, Ilwaco, Wash., Wed., Feb. 1, 1978 —5

Espys donate Oysterville church

Mrs. W. W. Little, Oysterville, said last Friday that the H. A. Espy family had donated the Oysterville church and adjoining lot to the Oysterville Restoration Foundation.

Mrs. Little, an Espy by birth, said the donation would count as the foundation's share toward the restoration of the church, the rest to be paid by the National Register of Historic Places, a subdivision of the Department of the Interior.

Mrs. Little said the money to be received would total more than $17,000. Half the amount was given last year and the balance will come piece by piece at the government's discretion.

Actual restoration work will probably commence next April, according to Mrs. Little, who said the project will be very closely supervised by government experts who will take the greatest pains to see that the church is put back in its original condition without any of the modifications done in later years.

Among the restorations mentioned by Mrs. Little were the removal of shingles placed around the originally open belfry to keep wind and rain out of the church. The raised platform in front of the pews will be returned to its originally semi-circular form and a sample of the old wall paper has been taken to allow its duplication as nearly as possible.

Once the church is back in shape the site will be marked with a bronze plaque received July 4, 1976 as part of Oysterville's Bi-Centennial celebration. Arrangements are being made to place the plaque just north of the church.

Mrs. Little said the church was built in 1842 by R.H. Espy at a cost of $1,500. Espy then donated it to a Baptist congregation of which he was a deacon, with the proviso that if the congregation ceased to use the church it would revert to him or his heirs.

Regular Baptist services were held in the church until the early 1940's according to Mrs. Little, although other denominations were allowed to use it too. Services are still held there on an irregular basis, and include many weddings and funerals. The weddings cost $25 each, which goes into the restoration fund.

In addition, the church remains open each day to sightseers, who are encouraged to put donations in the old poorbox. Any money collected will go first to the church restoration, then to that of other old buildings in Oysterville. (Editors note: a "poorbox John", one who stole from the poorbox, was reckoned in former times as the very lowest form of petty thief.)

Two other Oysterville buildings are slated for restoration this spring and summer along with the church. On is the Ned Osborn house, built in 1873 by a sailor who "swallowed the anchor" in Oysterville and intended to settle there with his intended bride. Unfortunately the bride died before Osborn could marry her, and he lived out his life in the house as a bachelor.

The Osborn house is now owned by Norman Dutchuck, Portland, who uses it as a summer house. The restoration will be paid for by federal matching funds.

The third house, called the Tommy Nelson house because of a former resident who lived there for 50 years, was actually built by William Taylor, who later moved to Ocean Park where he built the Taylor Hotel.

The "Nelson" house is the only one of the three being restored without government help, because the owner, Mrs. R. J. Glynn wishes to avoid the government supervision which would come with the money. Mrs. Glynn is sticking to her own money so she can have a few more modern features in her house newly bought from Theodore Holway, Oysterville than the exacting government experts would allow.

Mrs. Little said the Restoration Foundation was hoping to get funds from private persons, especially those with ancestral connections to Oysterville. However, according to Mrs. Little the Foundation will not make a fund-raising drive until it has been assigned an official tax exemption number from the Internal Revenue Service which would make the donations deductible.

In addition, Mrs. Little admits to one "pie-in-the-sky" hope, that money might be found to improve the community's turn-of-the-century look by burying the anachronistic telephone and power lines which have appeared since the town was built. However, this would cost at least $27,000 for the town lines plus $700 for each set of house wires. Benevolent billionaires take note!

AN ECUMENICAL FUTURE. Once the town's National Historic status had been established, the residents of Oysterville quickly formed the Oysterville Restoration Foundation, a nonprofit corporation whose first task was to restore the church. Meanwhile, the Espy family, following the provisions of the old deed, had the church divested by the Baptist synod. They then established ownership and gifted the church to the Oysterville Restoration Foundation so that the organization could begin the fund-raising for the old structure's restoration. In 1982, the fully restored historic building was rededicated as an ecumenical church for use by the community at large. (EFC.)

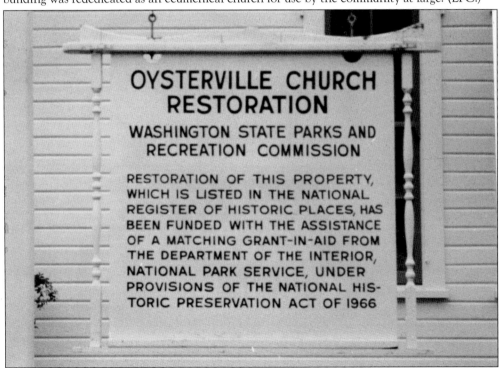

OYSTERVILLE CHURCH RESTORATION

WASHINGTON STATE PARKS AND RECREATION COMMISSION

RESTORATION OF THIS PROPERTY, WHICH IS LISTED IN THE NATIONAL REGISTER OF HISTORIC PLACES, HAS BEEN FUNDED WITH THE ASSISTANCE OF A MATCHING GRANT-IN-AID FROM THE DEPARTMENT OF THE INTERIOR, NATIONAL PARK SERVICE, UNDER PROVISIONS OF THE NATIONAL HISTORIC PRESERVATION ACT OF 1966

POPULARIZING OYSTERVILLE. A solitary stone bench sits in the meadow across from the Red Cottage where author/wordsmith Willard Espy spent his last 20 summers. On it, inscribed in his hand, are words from his 1977 book, *Oysterville: Roads to Grandpa's Village*: ". . . I can watch the slow breathing of the bay, six hours in and six hours out." Through the book, Oysterville gained national attention, bringing untold numbers of visitors to the village. Meanwhile, at the north end of town, Les Driscoll and his son, Dan, began to sell their fresh oysters out of the old Northern cannery building. In 1991, Dan opened Oysterville Sea Farms there and began the arduous task of restoring the building, successfully re-establishing it as a center of the shellfish industry in Oysterville. (Above, Pat Fagerland; below, Sydney Stevens.)

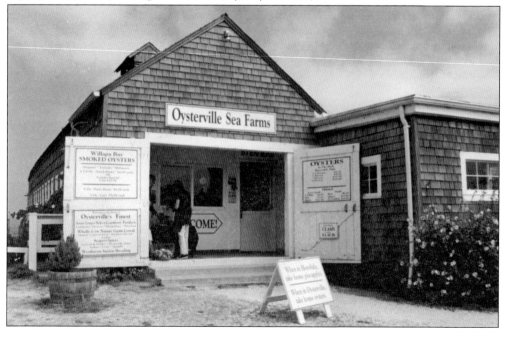

HONORING THE PAST. Two traditions of Oysterville's pioneer past have been revitalized in recent years. An annual regatta is held each summer, with the competition nowadays being among recreational sailors using Laser class sailboats rather than among oystermen in their plungers. Cousins Chris Freshley and Tucker Wachsmuth, both descendents of early oysterman Meinert Wachsmuth, take turns hosting the event, which villagers consider the highlight of the season. Also reminiscent of the past is the replica 1841 Mountain Howitzer that is fired at Oysterville celebrations, on national holidays, and at other occasions of importance. The cannon was purchased by the Honorary Oysterville Militia, which was formed in 2004 by "General" Nyel Stevens to commemorate Oysterville's sesquicentennial celebration and in remembrance of Major Espy and the members of the Pacific County Regiment of Militia of Washington Territory, 1855. (Sydney Stevens.)

CHANGING TIMES. The character of Oysterville has changed greatly since its beginnings in the mid-19th century. The bawdy boomtown of hardworking, hard-drinking men hoping to strike it rich on the tideflats of Shoalwater Bay is now the stuff of stories. Also consigned to memories of the "good old days" are the shouts of children spilling out of schoolhouse doors and the quiet chitchat of women working over their quilt pieces. These days, with mobility and tourism drawing travelers to remote areas, Oysterville has become a desirable tourist destination and a fashionable place to have a vacation home. As the 20th century drew to a close, the village began to take on a gentrified air, with new residents from large urban centers bringing an unaccustomed sophistication to the weathered old oyster town. All villagers, old and new, work hard to preserve the historic character of the village, and even first-time visitors speculate on what the next century and a half will bring to Oysterville on Willapa Bay. (Sydney Stevens.)

BIBLIOGRAPHY

Barrett, Elinore M. "The California Oyster Industry." The Resources Agency of California Department of Fish and Game, Fish Bulletin 123, 1963.

Davis, Edgar and Charlotte. *They Remembered, Books I-IV*. Ilwaco, WA: Pacific Printing, 1981–1994.

Espy, Robert Hamilton. Oral History 1918. Espy Family Archive. Oysterville and Tacoma, WA: 1854–1999.

Espy, Willard R. *Oysterville: Roads to Grandpa's Village*. New York: Clarkson N. Potter, Inc. Publishers, 1977.

Feagans, Raymond J. *The Railroad That Ran by the Tide*. Berkeley, CA: Howell-North Books, 1972.

Florin, Lambert. *Washington Ghost Towns*. Seattle, WA: Superior Publishing Company, 1970.

Gibbs, James A. *Pacific Graveyard*. Portland, OR: Binfords and Mort, 1973.

Oesting, Marie. *Oysterville Cemetery Sketches*. Ocean Park, WA: 1988.

Ramsey, Guy Reed. *Postmarked Washington: Pacific and Wahkiakum Counties*. Lake Oswego, OR: Raven Press, 1987.

Swan, James G. *The Northwest Coast or Three Years' Residence in Washington Territory*. Seattle, WA: University of Washington Press, 1972.

The Sou'wester, Volumes I–XLIV. South Bend, WA: Pacific County Historical Society, 1966–2008.

Willapa Harbor Pilot, "Oyster Edition." South Bend, WA: 1906.

INDEX

126

www.arcadiapublishing.com

Discover books about the town where you grew up, the cities where your friends and families live, the town where your parents met, or even that retirement spot you've been dreaming about. Our Web site provides history lovers with exclusive deals, advanced notification about new titles, e-mail alerts of author events, and much more.

MADE IN THE USA

Arcadia Publishing, the leading local history publisher in the United States, is committed to making history accessible and meaningful through publishing books that celebrate and preserve the heritage of America's people and places. Consistent with our mission to preserve history on a local level, this book was printed in South Carolina on American-made paper and manufactured entirely in the United States.

This book carries the accredited Forest Stewardship Council (FSC) label and is printed on 100 percent FSC-certified paper. Products carrying the FSC label are independently certified to assure consumers that they come from forests that are managed to meet the social, economic, and ecological needs of present and future generations.

FSC
Mixed Sources
Product group from well-managed forests and other controlled sources

Cert no. SW-COC-001530
www.fsc.org
© 1996 Forest Stewardship Council

Find Your Place in History.